IMAGES
of America

STAR ISLAND

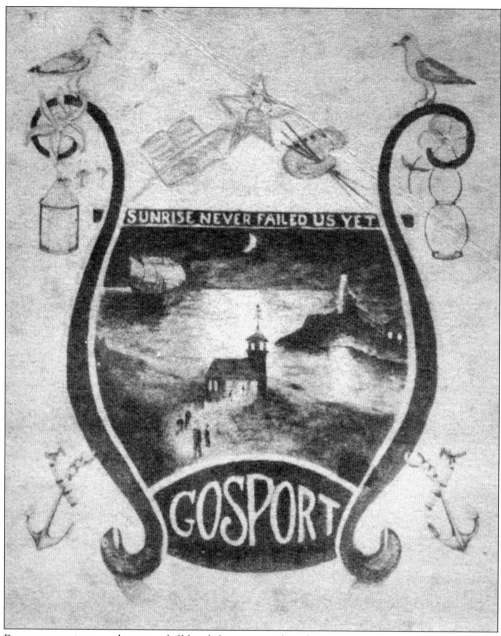

Poets, songwriters, and artists of all kinds have created works to capture the spirit of Star Island. This illustration, found in the Star Island Corporation's collection, is one of them. (Courtesy of Star Island Corporation.)

ON THE COVER: The cheer "You Will Come Back" is a longtime traditional expression used each time someone leaves the island. The sign is in a significant position in the dining room, the place where everyone meets daily to share meals and friendship. (Courtesy of Star Island Corporation.)

IMAGES of America
STAR ISLAND

Donald J. Cann and Gayle Kadlik

ARCADIA
PUBLISHING

Published by Arcadia Publishing
Charleston, South Carolina

Printed in the United States of America

Library of Congress Control Number: 2014947954

For all general information, please contact Arcadia Publishing:
Telephone 843-853-2070
Fax 843-853-0044
E-mail sales@arcadiapublishing.com
For customer service and orders:
Toll-Free 1-888-313-2665

Visit us on the Internet at www.arcadiapublishing.com

CONTENTS

ACKNOWLEDGMENTS

The authors wish to acknowledge the many people and organizations that offered invaluable help in contributions of photographs and information for this book. We thank members of the staff at the Star Island Corporation office, including Joe Watts (chief executive officer), Justina Maji (conference center director), Kate Brady (office manager), Caitlin Selby (Vaughn curator), and Melissa Saggerer (past Vaughn curator). Special thanks go to Kyle Belmont, program and outreach coordinator, who took a few boat trips and hikes up to Vaughn after the season was over to gather some particular photographs for our use. Marshall Frye and Nate Trachimowicz also provided some much-appreciated off-season on-island assistance with photography. Ann Madzar offered valuable suggestions. Thanks go to old Shoalers Ken and Sara Schoman, who offered photographs and advice.

Star Island Corporation's collection is made up of photographs from many contributors. Many thanks are extended to all.

We are grateful to Tom Hardiman, Carolyn Marvin, James Smith, and the staff at the Portsmouth Athenaeum for supplying easy access to the Star Island Corporation's collection, which is housed at the athenaeum. We appreciate the assistance of Alex Herlihy at the Rye Historical Society and Nathaniel Wiltzen at the National Archives in Waltham, Massachusetts. Jane Winton and Karen Shaft of the print department at the Boston Public Library, the Leslie Jones Collection, were extremely helpful in locating photographs of the *Squalus* disaster. Thanks go to Lea Crunk and Lea French Davis of the Naval History and Heritage Command. The staff at the Concord Free Library, Concord, Massachusetts, kindly supplied workrooms for us. The Star Island Heritage and Artifacts Committee members have been encouraging and supportive during our project.

We are very appreciative of the support and attention of our title manager, Caitrin Cunningham, for her guidance and attention to detail. She has kindly kept us on schedule. All photographs are courtesy of the Star Island Corporation unless otherwise noted. Abbreviations for noted contributors are the National Archives, Waltham (NA, W); Boston Public Library, Leslie James Collection (BPL, LJC); and Donald J. Cann (DJC).

Gayle Kadlik would like to thank all who supported her in this project, especially her husband, John, and their three sons—Johnny, James, and Christian. A special thanks goes to her late mother, Gladys Josephine Mathieu, for introducing her to her Isles of Shoals ancestry.

Donald Cann would like to thank his wife, Janet, and his daughters, Emily and Jessica Cann—all of whom were conferees and Pelicans at one time. Janet celebrated her 50th year on Star Island during Pelican Reunion in 2014.

INTRODUCTION

In summer of 1896, somewhere between divine intercession and the chaos theory, Thomas and Lilla Elliott arrived at the Isles of Shoals. As Lilla was ill, she wanted to spend some time at the ocean, so they made a last-minute change of plans. Rather than visit their usual Unitarian religious conference center on Lake Winnipesaukee, they went to the Oceanic Hotel on Star Island. At that time, the hotels were not doing very well. The Elliotts proposed bringing a religious conference to Star Island, and they promised to fill the hotel. With some skepticism about Unitarians, Harry Marvin, the hotel manager at the time, agreed. Thomas formed the interdenominational Isles of Shoals Summer Meetings Association and filled the Oceanic Hotel, as well as the Appledore Hotel, with 610 guests the next summer, in July 1897.

The following year, the group held services in the meetinghouse, with overflow on the rocks outside. This became the most meaningful part of the conference—the candlelight service, which continues today.

In 1914, the Congregational Summer Conferences Association, later known as the Isles of Shoals Congregational Conference, formed in order to conduct conferences at the Isles of Shoals.

In 1915, the island came up for sale on short notice. Lewis Parkhurst, a wealthy businessman from Portsmouth and a longtime Shoaler, paid $16,000 to purchase the island for the Summer Meeting Association. Shoalers immediately organized to reimburse him, and the corporation, made up of representatives from the Unitarian and Congregational conferences, was formed and chartered in Massachusetts for the purpose of buying Star Island from Parkhurst and continuing the religious and educational conferences. The Star Island Corporation was officially established.

In the last 100 years, not only have the infrastructure, the landscape, and the daily workings changed, but also the conferences themselves. The number of conferences has grown to 61 in the 2014 season. They might include 200 conferees for a weeklong stay to a weekend workshop of 20 people. The management and conferences have learned to interact and interface the different programs that might take place concurrently.

These changes, improvements, and increase in attendance at conferences now require 100 summer staff and 8 year-round staff. Over 500 volunteers help to open up, clean up, and get things going in the spring for the new season.

Each conference is self-administered, with conference chairs arranging for speakers, workshops, childcare, and registration. Conference administrators work closely with the year-round island administrators to make each conference work to its highest potential. Most of the conferences are family-centered, with activities for all ages. Most have a theme or program with guest speakers or workshop leaders.

A typical day at Star Island might include a morning dip, called the Polar Bear Dip. Breakfast comes soon after, and morning programs, exercises such as yoga, tai chi, crafts, speakers, and chapel occupy one's time. The many rocking chairs on the porch are always full of knitters, musicians, and people discussing issues related to the week's program or just chatting. There

might be a drum circle at one end of the vast porch and a few folks re-caning needy rocking chairs at the other end.

The large bell outside the dining room plays a strategic role for schedules. At mealtime and program start time, the bell is rung. In the afternoon, there are opportunities for softball, tennis, basketball, art activities in the art barn, swimming, walking, rock hiking, snacking on ice cream and lime rickeys, or even a nap.

Highlights of the week include the conferee-Pelican softball game, a long-standing competition. It is the time of week when the big old scoreboard is carried out and leaned against the well house. There are many who watch and cheer from the porch. Star Island has its own set of rules for softball, which have been documented on special T-shirts, so if you forget the rule, you can read it on your friend's back.

The weekly bonfire on the rocks near the summerhouse allows for some island-related ghost stories and marshmallow toasting. The Pelican Show encourages members of the seasonal staff to show off their many talents through musical performances, skits, and clever banter. Everyone looks forward to the show.

An evening will end with a chapel service, with conferees carrying glass lanterns lit with candles up the path to the chapel. Music wafts across the island during a service. Then on to ice cream at the snack bar and late-night chats or games in the lobby. All of one's experiences contribute to friendships and memories of Star Island.

Projects such as this book are a synthesis of the history and lives of many people and events. Star Island is a special place to so many that it is difficult to grasp completely in a photographic essay the history and emotional attachments to each individual's experiences there. We have tried, in this second book about the Isles of Shoals, specifically Star Island, to use photographs that are of interest and bring back the fond memories of conferees, Pelicans, Penguins, and the many others who have made contributions and memories on Star Island.

There are many unidentified people in these photographs, as well as those not seen here, who made major contributions to the preservation, growth, and well-being of the island and all who have had the privilege of the experience. We want to acknowledge all of their important contributions to island life and our memories.

Images of America: *Isles of Shoals*, our first book on the area, was published in 2007. The first book presents a photographic history of the shoals, chronicling the late 19th century to the middle of the 20th century. Each island is represented. Star Island, because of the town of Gosport, Oceanic Hotel, and the conference center, is a big part of the book. Still, there was much of the story of Star Island left out, which is the last 100 years of the conference center. Arcadia, the publisher, and the authors felt there was interest in another book that would tell the story of Star Island and the conference center that has been operating for the last century.

Parts of the introduction were adapted from the Star Island Lifespan Religious Education Conference website—and for more information about Star Island and its conferences or day trips and personal retreats, readers may visit www.starisland.org. Books of interest include *The Isles of Shoals: An Historical Sketch, The Isles of Shoals: A Visual History,* and *The Isles of Shoals in Lore and Legend. Among the Isles of Shoals, Ninety Years at the Isles of Shoals,* and *Sprays of Salt: Reminiscences of a Native Shoaler* offer firsthand accounts of life at Star Island.

In this time, changes have taken place on the island, but, in spite of the changes, the island has remained the same. There is sameness in its beauty, mysteries, and the spirit of fellowship gained in participating in the experience and life of Star Island. We hope that readers will remember their own experiences on Star Island and relate them to the experience others had on the island over the last 100 years, maybe an understanding of the experience that has made Star Island each person's "Spirit's Home."

One

BEGINNINGS, CONFERENCE TRADITIONS, AND OTHER HAPPENINGS

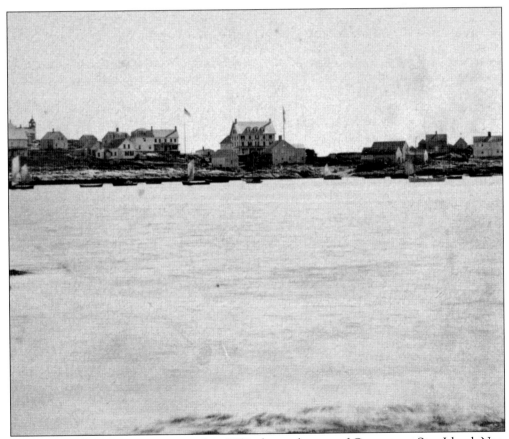

At the time this image was captured in 1852, the settlement of Gosport on Star Island, New Hampshire, still existed. Incorporated as a town in 1715, Gosport was populated by over 100 souls. These stoic people, mostly fishermen and their families, lived and died here until the township dissolved in 1876, and Star Island was annexed to the town of Rye, New Hampshire.

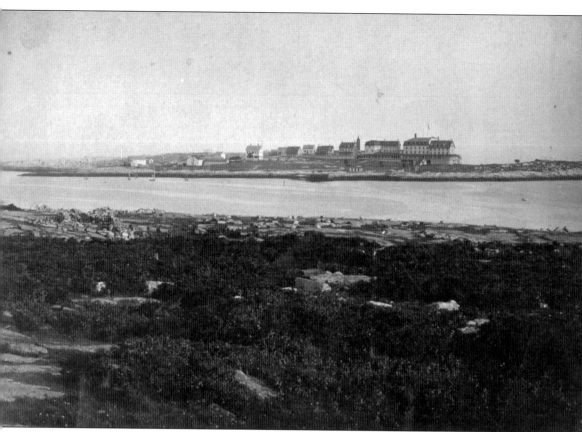

By the time this image was photographed in the late 1800s, the fishing village had dissolved and an era of tourism was beginning. The second Oceanic Hotel, comprised of several existing buildings, is visible on the right. The inscription on the reverse indicates that Charles A. Whitney of Boston and Cambridge, Massachusetts, purchased this photograph in the 1890s when he played in the orchestras at both the Oceanic Hotel and the Appledore Hotel.

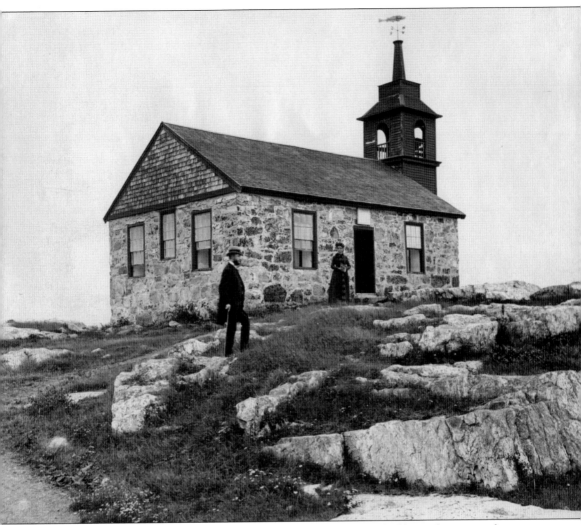

This chapel sits upon the highest point of Star Island. The idea of holding religious conferences here was born in 1896 when Thomas and Lilla Elliot visited the Isles of Shoals. In 1897, the conference era at the Isles of Shoals commenced. This image was captured in the 1880s. According to its inscription, the gentleman seen here with his wife is believed to be the rector and a relative of early Gosport minister Rev. John Tucke.

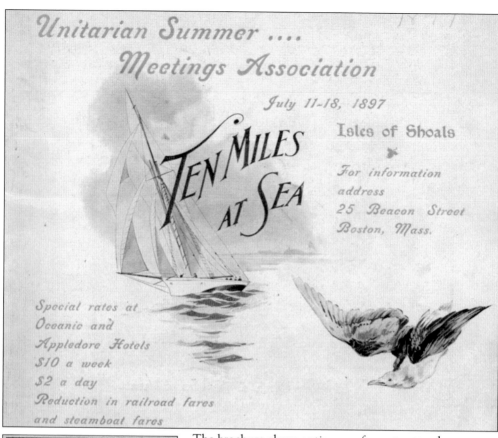

Unitarian Summer
Meetings Association

July 11-18, 1897

Isles of Shoals

TEN MILES AT SEA

For information
address
25 Beacon Street
Boston, Mass.

Special rates at
Oceanic and
Appledore Hotels
$10 a week
$2 a day
Reduction in railroad fares
and steamboat fares

UNITARIAN SUMMER MEETINGS

At the
Isles of Shoals
New Hampshire
July Seventh
to Fourteenth
Nineteen hundred
and one

The brochure above entices conferees to attend Unitarian summer meetings. It advertises amenities offered at the Oceanic Hotel, including "a fine Billiard Room, a large Ball Room, Bowling Alley and Lawn Tennis Court." It also touts "a large fleet of fine boats for sailing or rowing, manned by experienced skippers" and mentions an orchestra that was engaged for the entire season—presumably the same orchestra that employed Charles Whitney. Also advertised is an abundance of large codfish waiting to be caught just minutes from Star Island's shores. There is even a prize offered each season for the guest who catches the largest cod. In 1897, the record codfish caught weighed 76.75 pounds. The brochure on the left was printed in 1901.

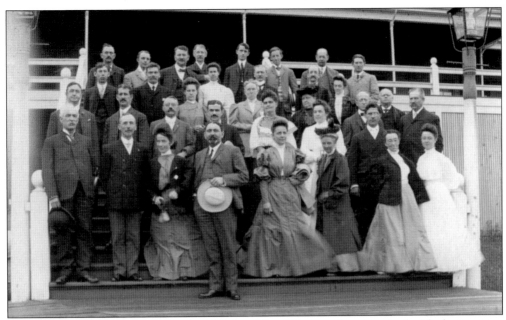

And so the conference era begins. In 1915, Star Island Corporation organized with the intent to buy Star Island and ensure the continuation of its beloved conferences. In the spirit of fellowship, the corporation was composed of both Unitarians and Congregationalists. A fundraising campaign for money to purchase the island was launched. In 1916, the Star Island Corporation purchased the island out from under another buyer for $16,000—buildings and all. Seen above in one of many conference traditions still upheld, a group poses for a photograph on the front steps of the Oceanic Hotel in June 1905. Below is another group from a conference, labeled "The Gang" and enjoying the same tradition in 1929.

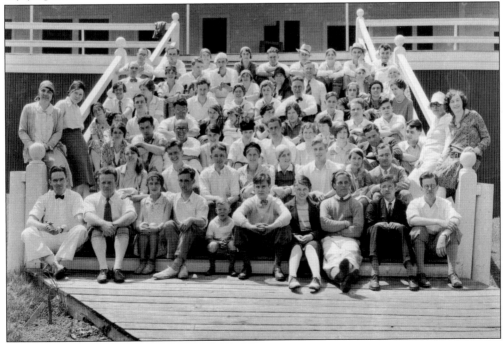

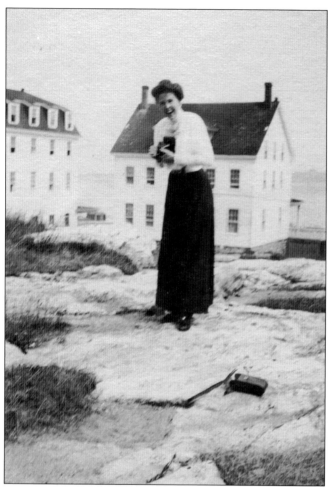

These two photographs predate the formation of Star Island Corporation. The one at left is of a laughing Mary Lawrence and dated 1910. Lawrence holds a camera, and the camera case lies nearby. Perhaps she is on her way to the front steps of the Oceanic Hotel to act as conference photographer. Buildings known as Cottage A (right) and Gosport (left) are visible in the background. Below, a group horseplays for the camera. The person third from the left appears to be a man masquerading as a woman. One wonders if the gentleman to his right is a ship's captain, judging from his outfit, or merely pretending to be.

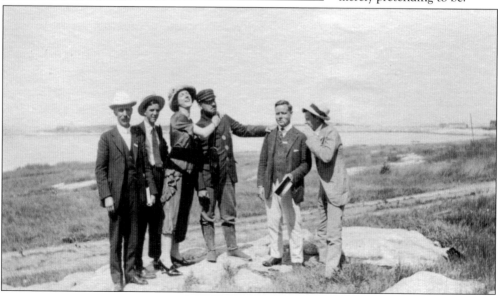

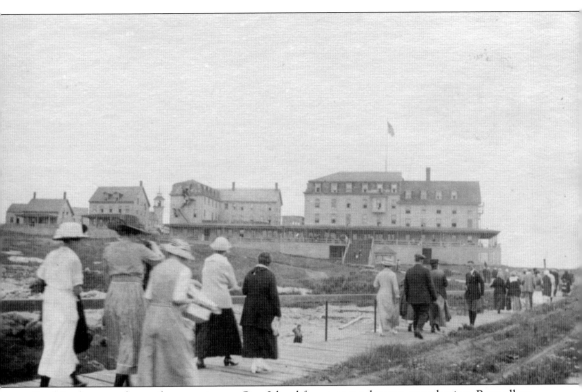

In this photograph, conferees arrive on Star Island for an annual summer gathering. Regardless of which conference they are attending, it is sure to be a week filled with learning, discovery, unique experiences, traditions, and a strong sense of community and camaraderie. Many of them will return year after year and retain friendships born here for the rest of their lives.

One of the first orders of business upon arrival on Star Island is attending the "Fire and Water" talk in Elliott Hall, seen here in 1962. This mandatory orientation session lasts about 45 minutes and ensures each conferee is well acquainted with the necessary safety and policy information, including the restriction of open flame to prevent the devastating consequence of fire and to conserve the ever-precious water. Note the wooden benches, which have since been replaced by stackable chairs.

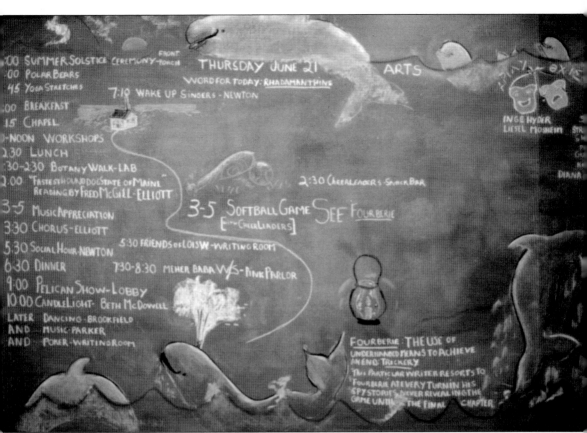

This is a photograph of the all-important conference chalkboard, located in the lobby of the Oceanic Hotel. This one is from an arts conference. Conference chairs use this to communicate to conferees the times and locations of the day's events, which include traditions looked forward to each year. Note that this conference even has cheerleaders. They are scheduled to meet in the snack bar prior to the game.

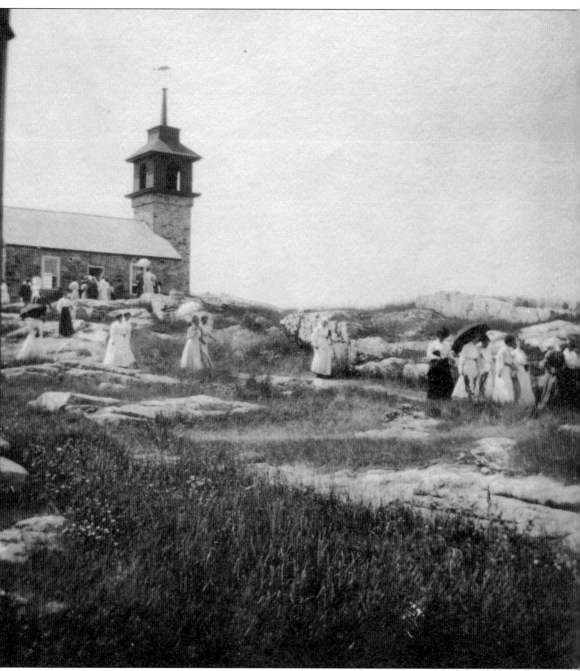

This early image shows attendees departing a chapel service. As current conferees can attest, chapel services have been at the center of conference traditions and held here since before the beginning of the era. One long-standing custom is the evening candlelight service. Candle lanterns are lit beneath the porch and carried up the path to the chapel in a silent procession. There, they are hung on the wall sconces and the chapel glows with soft light. Of interest in this photograph is that mostly women are in attendance at this particular observance, with the exception of the gentleman under the umbrella near the bell tower—perhaps the minister.

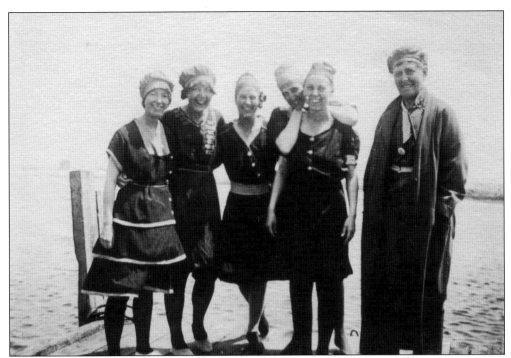

A brisk dip in the designated swimming area off the Star Island dock has also been a long-standing conference tradition. Participants in this ongoing morning ritual are referred to as Polar Bears. Above is a group of Polar Bears gathered on the dock, about to brave the cold Atlantic waters around 1900. Below, another group is enjoying the tradition in 1937. Bathing suit fashion had certainly gone through a transformation during those years. Note the position of the wooden gangway, indicating a high tide. Today, the gangway is constructed of aluminum. Also of note is Cedar Island, visible in the background.

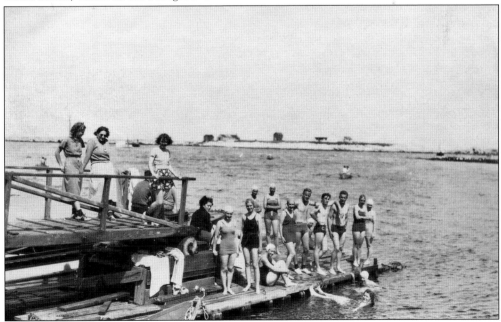

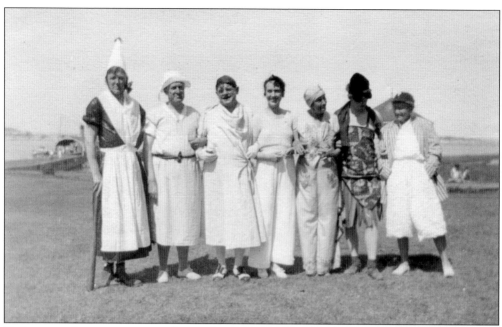

Today, a conference is not complete without a softball game pitting Shoaler (conferee) against Pelican (island staff). The game is played in the afternoon on the front lawn of the Oceanic Hotel. Onlookers line up on the hotel porch above the playing field toting raspberry lime rickeys or dishes of ice cream purchased from the snack bar. A good vantage point is important, and people come early to stake out a rocking chair in their favorite spots. The photograph above is from the 1920s. This softball game is between the men and women of the conference, with one catch—both sexes cross-dress. In the more contemporary image below, it is apparent that the Shoalers won this particular match.

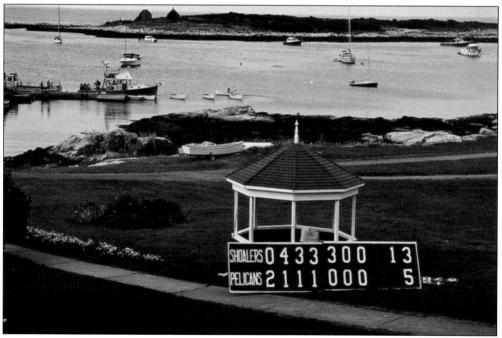

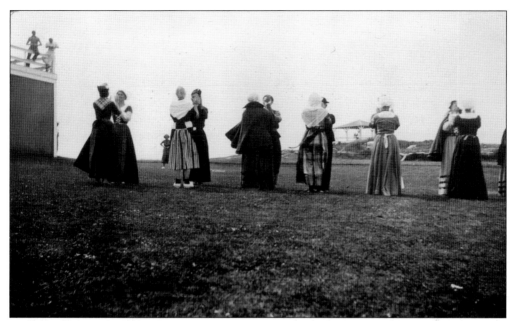

Each conference usually has a theme of sorts. Pageants and other theatrics are a favorite addition to any conference's schedule. In this photograph from about 1930, a group of conferees is dressed in Dutch costumes. The people are paired up and appear to be performing a dance skit. Perhaps this conference's theme for the week was embracing music and dance from cultures around the world.

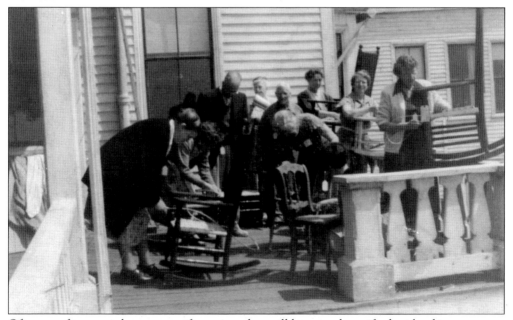

Often, conferences take on a specific project that will better or beautify the island in some way. Porch sitting on the front veranda of the Oceanic Hotel is one activity that almost every Shoaler makes time for during his or her stay on the island. This group, from the late 1940s, is re-caning some of the porch rockers—a sometimes tedious but very necessary undertaking appreciated by all.

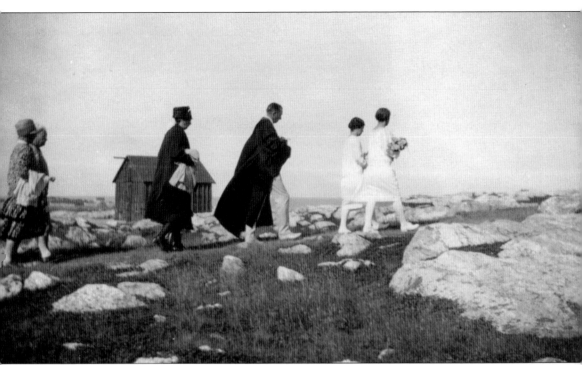

These next two images, from the mid-1920s, depict a memorial service for Minnie Ward Jackson and others. Rev. Houghton Page, seen walking behind the two women to the right, is presiding over the solemn ceremony. The participants follow a path leading past what is known today as the art barn. Today, a memorial book is kept current and is located in the hotel lobby.

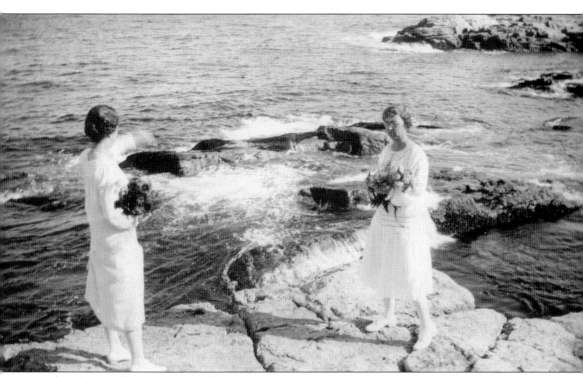

In this photograph, the women—identified as Mary McCarthy and Margaret Emilio—are perched atop the rocks overlooking the east-facing geological area known as the marine gardens. Sadly, there have been many memorial services over the years. Today, Shoalers continue to memorialize each other through the recently constructed memorial garden. Etched stones are ceremoniously placed within a compass formation designated in an area within the stone village.

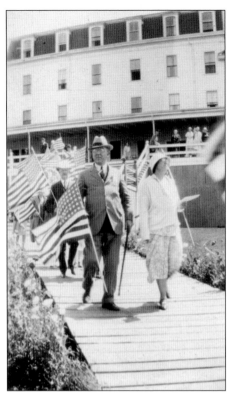

In 1922, arriving conferees were welcomed on the pier by greeters. Each greeter holds an American flag. They would form a line on either side of the pier and hold the flags up so that the tip of each touched its opposite. The arriving conferees passed beneath this patriotic makeshift tunnel. In a show of patriotism today, the Fourth of July is celebrated on Star Island with a parade, complete with floats created by imaginative and resourceful island staff. Everyone gathers on the front lawn of the Oceanic Hotel to watch as the procession passes. Below, a young conferee celebrates the Fourth of July.

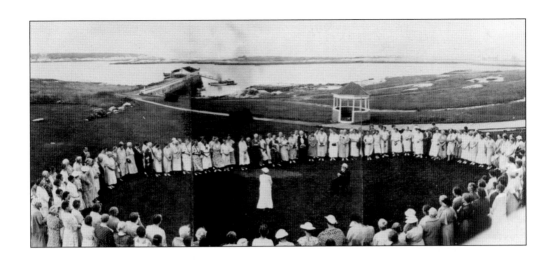

Since its inception in 1924, the General Alliance Conference was always one of the best attended. With the exception of 1943 and 1945, this conference met yearly from 1924 through 1962. In this photograph above, taken in 1933, the conferees form a friendship circle around Oscar Laighton, known as "Uncle Oscar." Below, a group of conferees is about to enjoy a game of tennis. At the time this photograph was taken, island staff were not allowed on the tennis court. Today, they often enjoy competitive games of basketball on the court. Note the fire escapes on the buildings in the background. These no longer exist and have been replaced by enclosed ones in the rear of the buildings.

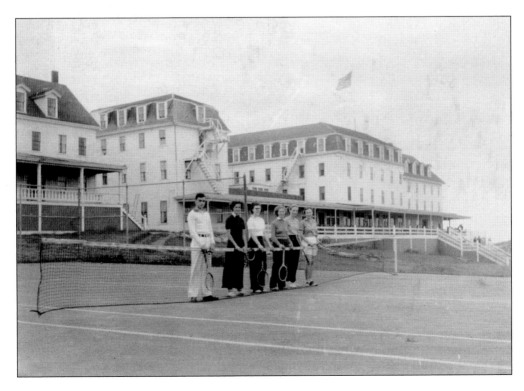

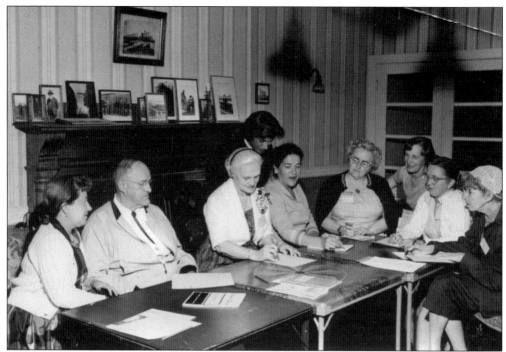

This photograph shows a writing club group meeting in the pink parlor of the Oceanic Hotel. Seated at the table, third from the left, is Hildreth Frost. Her husband, Robert, managed the hotel during the 1950s. An abundance of prose—both amateur and professional—has originated from Star Island experiences. Note the interesting framed photographs on the mantel behind the group. Below, the dining room is decked out for banquet night. Every conference culminates with this much-anticipated feast. It is bittersweet, however, as it signals the end of their cherished week on Star Island. In the morning, the current conference must depart and make way for the incoming conference. (Above, courtesy of Sara Frost Schoman.)

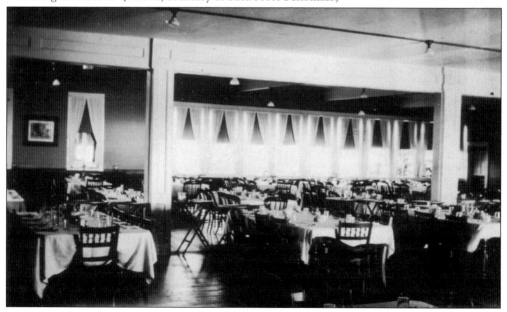

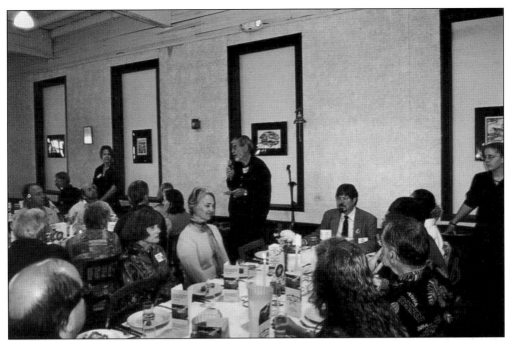

The conference chair always has some closing statements, recognition for those especially helpful individuals, and last-minute announcements to deliver during dinner. Note the lit candles on the tables. Also, the bell hanging from the ceiling to the right of the speaker is used to gain the attention of diners. During the 1920s, a theatrical performance by fellow conferees was expected during dinner—right there in the center aisle of the dining room. Dinner is followed by a "clap out" for the dining room staff to show appreciation for their hard work. Then, of course, there is the grand march. The photograph below was taken in the lobby of the Oceanic Hotel.

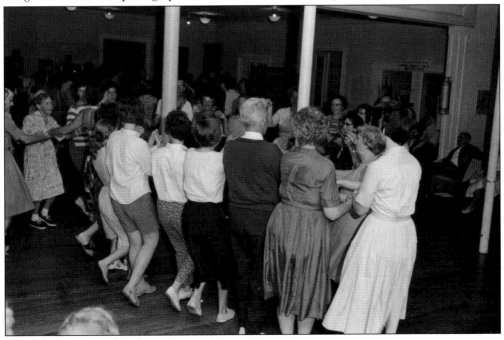

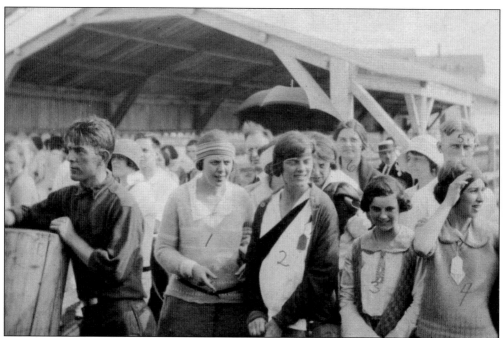

In this image, conferees from the early 1920s are on the pier awaiting departure from the island. Persons identified in the image are labeled with numbers one through six and are as follows: Marion Hoag (1), Virginia Frederick (2), Frances Bird (3), Peg Graham (4), Arthur Olson (5), and Ruth Twiss (6). No doubt they are awaiting the traditional send-off by island staff and others remaining on island. The photograph below shows the tradition continuing in the 1960s, as it still does today.

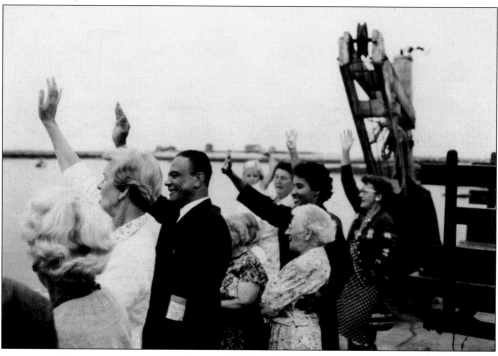

Two

SHADOWS OF WAR ON STAR

The military history of Star Island starts with the construction of Fort Star around 1653, at the entrance of the harbor where the summerhouse now stands. In 1692, the fort was restored, and it was repaired and mounted with nine guns in 1745. The fort was garrisoned with provincial forces during the French and Indian War, 1754–1763. The fort was closed during the American Revolution, and the guns were sent to Newburyport, Massachusetts. (Courtesy of DJC.)

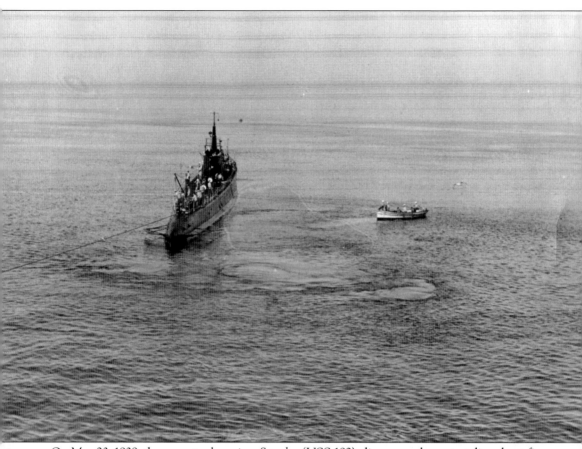

On May 23, 1939, the newest submarine, *Squalus* (USS 192), disappeared on a test dive about five miles to the southeast of Star Island in 243 feet of water. Here is the *Sculpin* (USS 191), the first vessel to find and contact the *Squalus*, standing by at the site. The rescue of the 33 survivors and the stricken submarine brought the attention and prayers of the Shoalers and nation. (Courtesy of NA, W.)

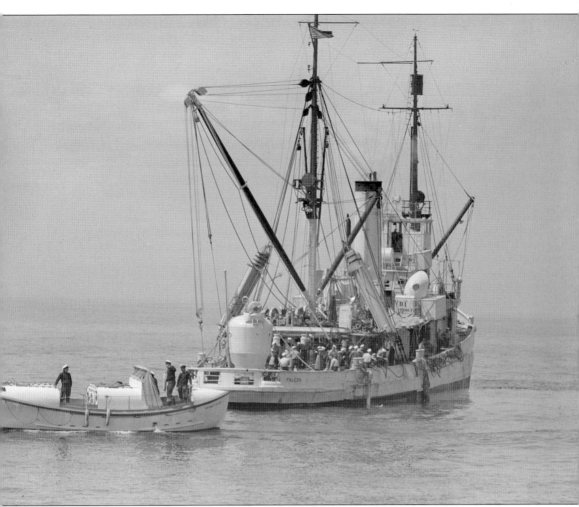

This is the Navy's submarine rescue ship *Falcon* (ASR 2) with the McCann rescue chamber. The small boat is a 36-foot Coast Guard motor lifeboat from Portsmouth. The *Falcon* arrived at 11:30 a.m. on May 24, 1939. The never-before-used McCann rescue chamber is seen on the fantail of the *Falcon*. The manned rescue chamber made five descents. The *Squalus*'s captain and one civilian as well as 31 sailors were rescued. (Courtesy of BPL, LJC.)

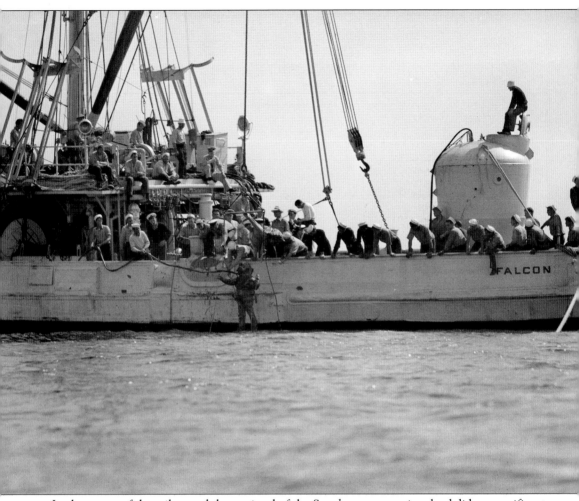

In the rescue of the sailors and the retrieval of the *Squalus*, everyone involved did a magnificent job. The Navy divers were singled out, not only for their skills but also for their bravery. There were 648 dives made in the rescue and salvage operation of the *Squalus*. Four divers were awarded the Medal of Honor for performing beyond the call of duty in most-hazardous conditions. (Courtesy of BPL, LJC.)

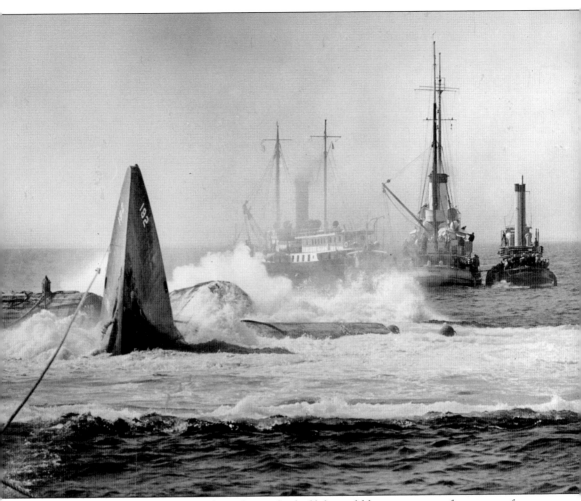

It was decided to salvage the *Squalus*. The method of lift would have a system of pontoons, fore and aft and at different levels, so by controlling the buoyancy the sub could be eased up and towed. This is the first attempt to lift the sub, on July 13, 1939. The bow came rapidly to the surface. It was August 12, 1939, before the second and successful lift of the *Squalus*. (Courtesy of BPL, LJC.)

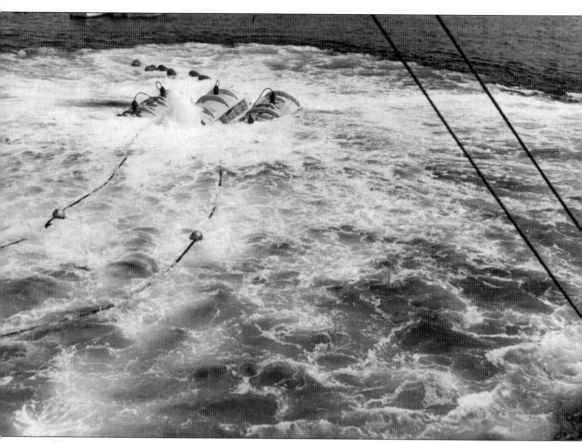

This photograph shows the pontoons breaking the surface in the second attempt to lift the *Squalus*. The heavily flooded stern had three pontoons at about midway down—one at three quarters down and two just above the deck. On the forward section, which was not flooded and therefore lighter, the system of pontoons was three at a little less then midway down and only one a little above the deck. (Courtesy of NA, W.)

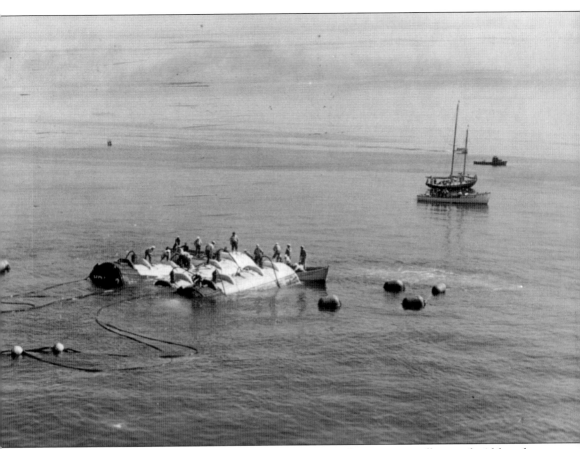

Divers have boarded the surface pontoons to close the vent so the pontoons will not sink. Although the second try to raise the *Squalus* was successful, getting the sub to the Portsmouth Shipyard was not easy. Bad weather, getting hung up on the sea bottom, and more all delayed progress. However, by mid-September, *Squalus* arrives at the Portsmouth Shipyard, 113 days after she sank off Star Island. (Courtesy of NA, W.)

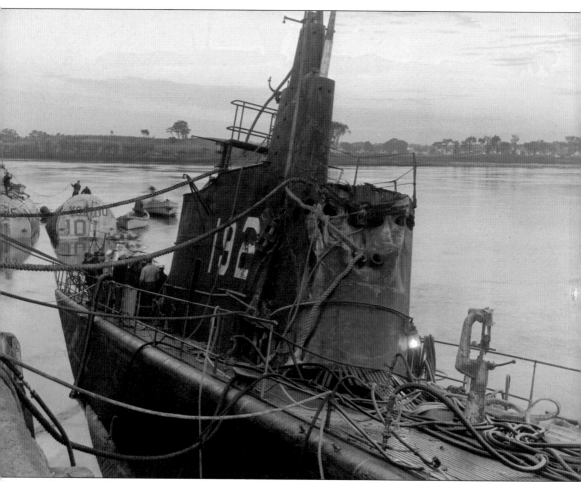

In September 1939, the USS *Squalus*, battered and still holding the bodies of 23 drowned sailors, is tied up at the Portsmouth Shipyard. The damage to the conning tower and foredeck occurred during the rescue and salvage operation. Note the two pontoons behind the sub. (Courtesy of BPL, LJC.)

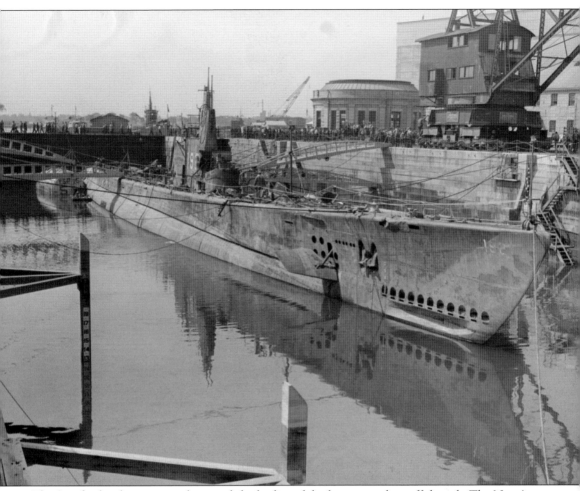

The *Squalus* has been pumped out and the bodies of the lost men taken off the sub. The Navy's investigation found that the engine main air induction valve was open. As to how or why it was open, the report is inconclusive. Because of the findings, new safeguards were installed on all existent submarines and added to all new submarines. The Navy never had another incident like the *Squalus*. (Courtesy of BPL, LJC.)

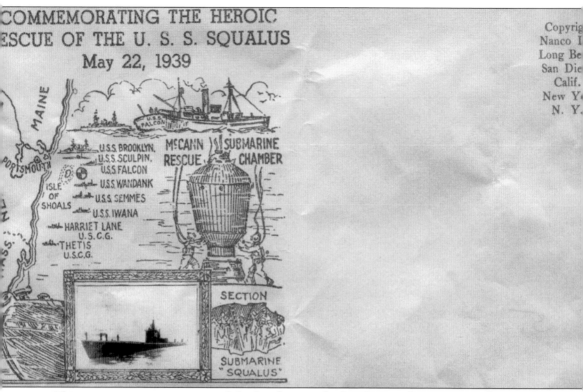

This is a commemorative cover of the *Squalus* tragedy. *Squalus* was decommissioned November 15, 1939, and recommissioned the USS *Sailfish* on May 15, 1940. One irony to come was that the *Sailfish* would sink the Japanese carrier *Chuyo* on December 4, 1943. The *Chuyo* was transporting prisoners of war, including crew members of the *Sculpin*, and 20 men lost their lives. None of these men were in the crew of the *Sculpin* in the summer of 1939. (Courtesy of the Naval History and Heritage Command.)

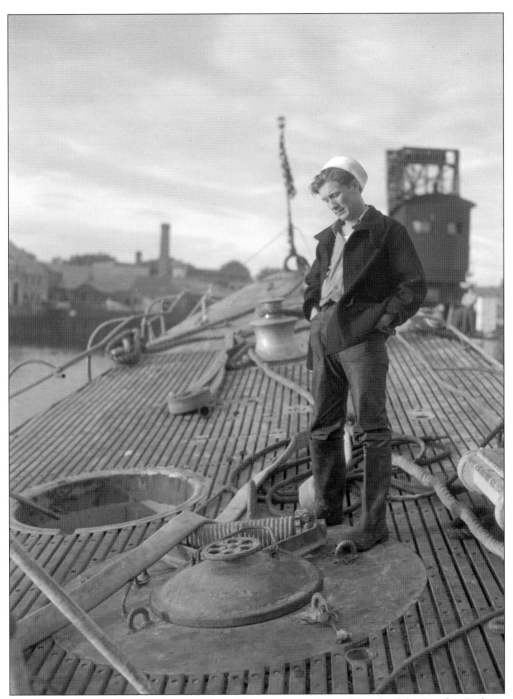

This shipyard worker has much to ponder as he peers at the forward hatch of the *Squalus*. Perhaps he is pondering the loss of life, the rescuing of the survivors, the recovery of the submarine, or what may have gone wrong and can it be fixed for the future. Perhaps his thoughts have turned to war looming in the nation's future and the role of the Portsmouth Shipyard. (Courtesy of BPL, LJC.)

Star Island Conferences were held in 1941, but Pearl Harbor ended conferences until the war was over. The military established installations on Appledore Island. The seven-story concrete Base-End Station tower (1944) remains. This tower was used for fire control of coastal artillery. The fifth story was for Battery Barry at Fort Dearborn, Rye. The sixth story was designated for Battery Curtis at Fort Foster, Kittery. The seventh story was for Battery Seaman at Fort Dearborn, and the roof had antiaircraft guns. The structure with the wooden water barrel on top was designed to have a fire-control radar antenna. Barracks, searchlights, and a pier were also built on the island. A secret Navy Magnetic Indicator Loop Station was on Appledore. This was an antisubmarine system of cables laid on the ocean floor running north and south of the Isles of Shoals to the mainland. A submerged submarine running over the cable loop would give a magnetic signature. The signature would be sent to the Harbor Entrance Control Post at Fort Stark, New Castle, for appropriate action.

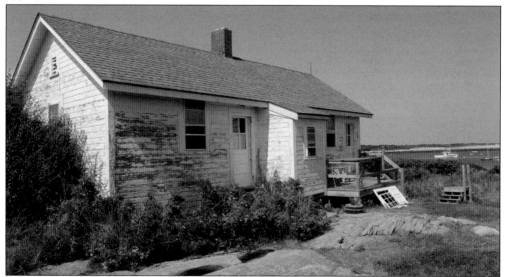

This building, which still stands on Star Island and is currently known as Doctors, was built by the Coast Guard, no doubt as part of its beach patrol mission. It is the only remains of the war on Star Island. Due to neglect of facilities during the war years, the corporation struggled after the war to refurbish the physical plant. (Courtesy of DJC.)

Three

BUILDING, GROUNDS, AND HOW THINGS WORK

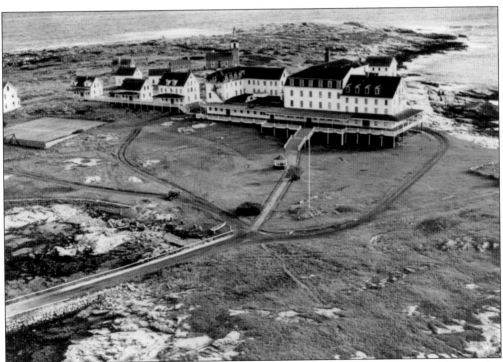

This chapter looks at Star Island's grounds and buildings from the 1890s to present. During this time, buildings were added and improvements were made to existing structures. Necessity of living on an island has fostered innovation when repairs are needed. The convenience and safety of the guests has been improved with modern technology. The view in the photograph is the island as it looked in late 1940s. (Courtesy of Portsmouth Athenaeum.)

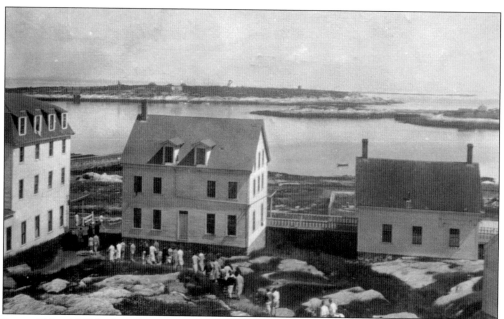

It would be 1915 before the Star Island Corporation organized for the purpose of acquiring Star Island and to allow continuance of conferences. In 1916, the corporation was chartered in Massachusetts, and it purchased Star Island. During World War I, conferences were held at the Wentworth Hotel in New Castle, New Hampshire. On-island conferences resumed after the war was over. This view of Star is from 1925. From left to right, the buildings are Gosport, Cottage A, and Cottage B.

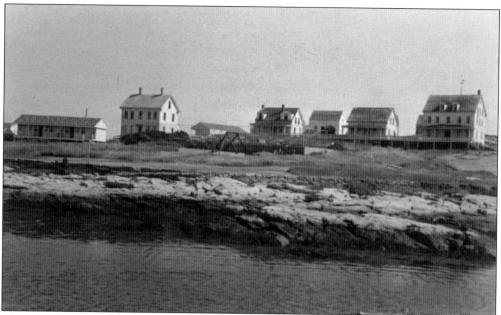

This photograph, taken after 1955, shows the 19th-century cottages and two of the hotel units built in the 1950s. From left to right, the first building is Founders (1953); the next is Cottage D, once the home of John Bragg Downs; the next (in background) is Sprague (1953), and all of the rest are former homes of Gosport residents acquired as hotel cottages.

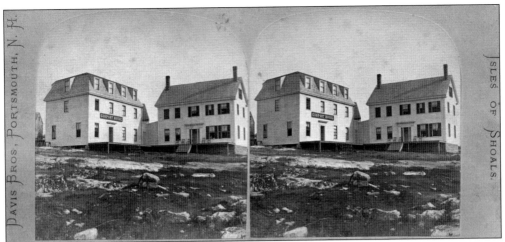

This is a stereograph of the original Gosport Hotel and the Berry House, owned by Origen Caswell. When Caswell's original home burned in 1866, he purchased the Berry House (right) and then built the Gosport Hotel (left). After the original Oceanic Hotel burned in 1875, owner John Poor rebuilt the hotel and incorporated the two buildings into the current Oceanic Hotel. The New Oceanic Hotel opened in 1876.

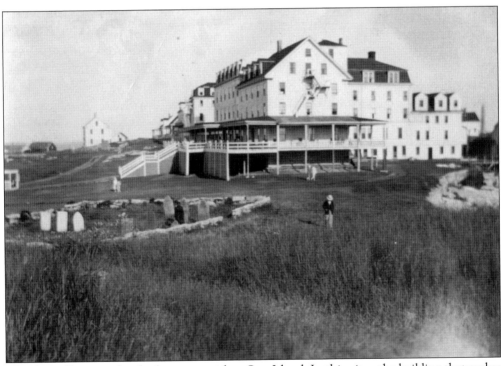

The Caswells were a family that prospered on Star Island. In this view, the building that makes up the right side of the Oceanic Hotel and has the large dormers to the rear is the Caswell House. The Atlantic House, a Caswell-owned building, makes up the south end of the Oceanic. The Caswell Cemetery is in the foreground of this photograph.

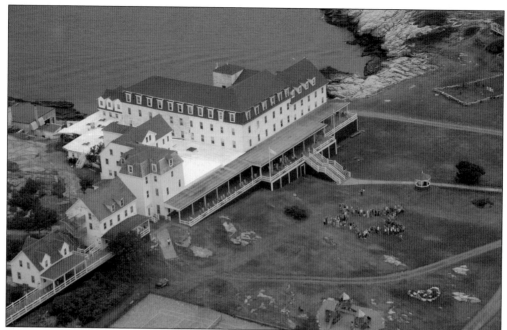

This current aerial view of the Oceanic Hotel shows how Poor incorporated the new mansard-roofed Oceanic with the Berry House and Gosport Hotel. Caswell House is seen in the back of the Oceanic, with its distinctive dormers. On the right end is the Atlantic House, another hotel that was incorporated in the new Oceanic structure. Enclosed fire escapes were added to Gosport and the Oceanic to meet current building codes.

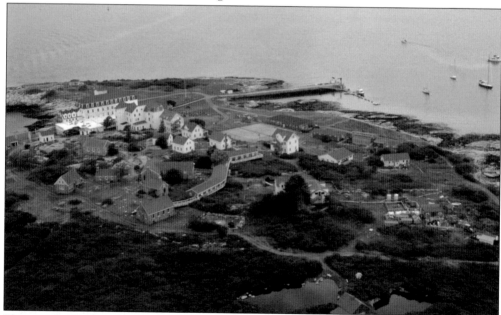

This aerial view shows the physical plant of Star Island in the early 21st century. Note the number of buildings that have been added since the 1940s view. Note the wastewater treatment plant in the picture to the middle right, built as a result of changes in the environmental laws regarding wastewater disposal. The plant is unique in that it operates seasonally and treats salt water.

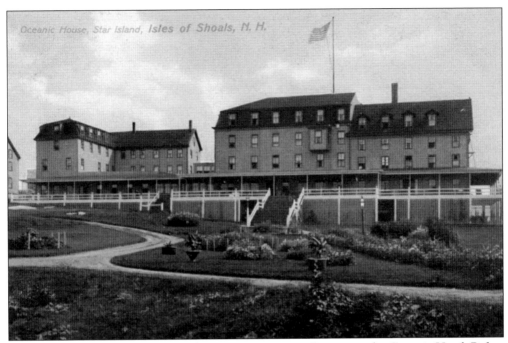

This view shows the flat-roofed porch section connecting Gosport to the Oceanic Hotel. Before this section was built, the porch wrapped around the ell part of the hotel and in front of Gosport House. The bay window on the hotel is a mystery as to when it was added and when it was removed. Note the gaslights on the walkway and porch banister.

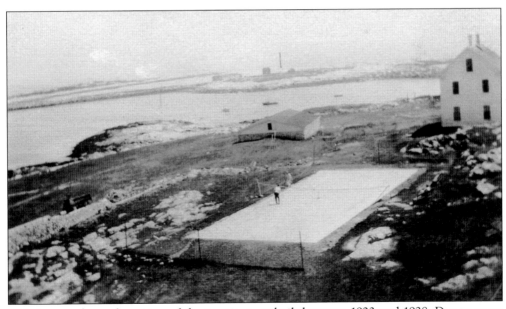

This is an early configuration of the tennis court built between 1923 and 1928. Due to usage demand, another tennis court was later added. The structures in the background are Cottage D (right) and a cistern (left) built on part of the foundation of the original Oceanic Hotel.

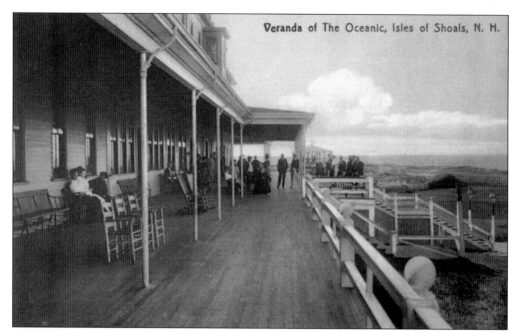

On the Oceanic's porch, few things have changed in modern times. The usage seems the same, with a definite change of the style of dress. Note the bay window, the gaslights, and the second set of stairs to the left of the main stairs. The gutter and drainpipe system seems to be supporting the porch roof.

Photographs of a shelter over the pier and the shelter over the pump are indicative of the 1920s. This photograph is recorded as 1925.

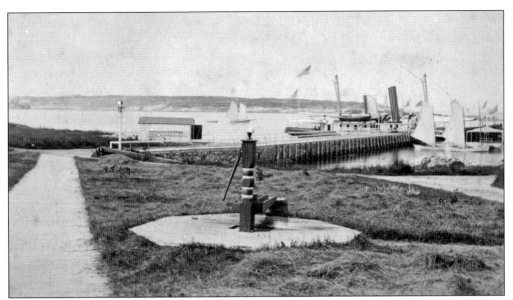

This photograph is dated August 21, 1885. Some fresh water was provided from the well on the front lawn. Fred McGill described the water used on Star as "three types: one for internal consumption, one for external application, and one for sanitary disposal." The waters are freshwater to drink, cistern water to wash, and seawater to flush.

Retail operations were conducted in the lobby at this counter, which later became the display window of the bookstore. Retail operations were divided into the bookstore here, the lobby store in the alcove, and the gift shop in a room by the main hotel staircase. The pipes on the wall are for heat.

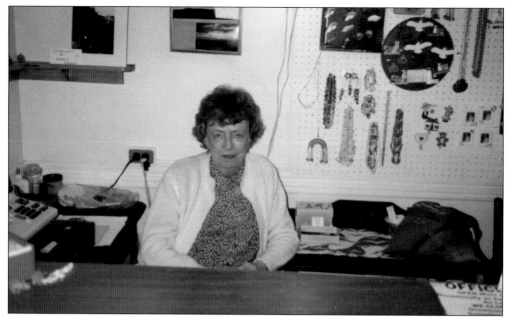

This is Marge Millett, longtime manager of the gift shop. While the bookshop and lobby store were a function of the island manager, the gift shop was operated by the Isles of Shoals Association (ISA). The ISA origins go back to the establishment of the conference center and acquisition of Star Island. ISA still supports the conference center with grants to continue its mission and now manages all three shops.

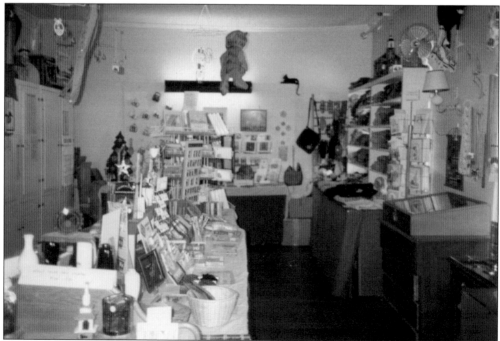

This is the gift shop in the 1970s. It was established in 1968 by Edith Doolittle and Ruth Coe. The ISA appoints a gift shop committee to hire a manager, select the merchandise, and recruit volunteers to staff the shops.

In the 1950s, the hotel offered lunch to day visitors. The kitchen did not know how many were coming; there was no radio or telephone service. In 1955, Ginny McGill enacted an experiment using pigeons. A pigeon would be brought to Portsmouth, and the messenger would put the number of lunch guests in a small capsule on the pigeon's leg. The bird would fly back to the island.

This is Ginny McGill in the room under the hotel gable, which became the pigeon loft. In the 1950s, the third and fourth floors of the Oceanic were not used for conference guests. The photograph shows McGill receiving the message the island messenger sent via the pigeon.

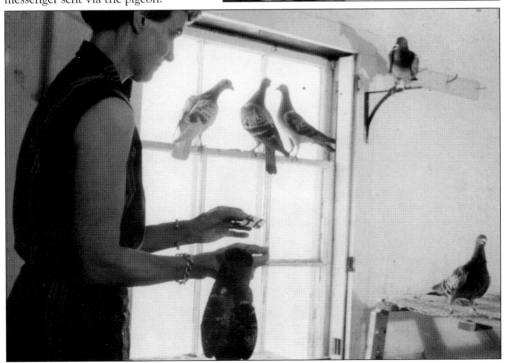

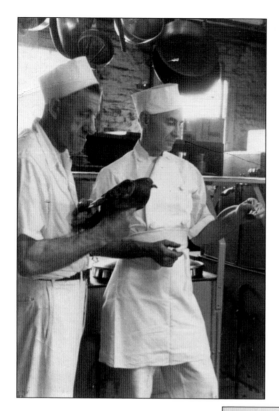

The chief cook, Patrick Russell (left), and his chief assistant, Lenny Reed, are receiving the exact number of guests for lunch. Once the carrier pigeons started their work at Star Island, the guesswork and tension of preparing lunches for an unknown number of guests was over.

In 1957, a radio-telephone service came to Star Island, but this did not put an end to the carrier pigeon service. The pigeons worked up to 1963, when the front desk used a citizens band radio. Today, the radio-telephone and even the citizens band radio seem ancient history with everybody using personal cell phones. Here, McGill is introducing a pigeon to what will make him obsolete.

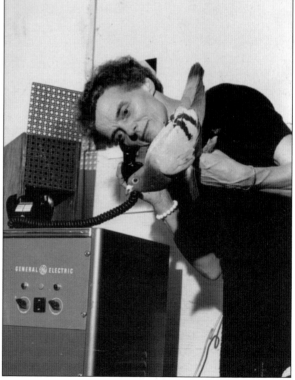

The head cook supervised a number of subdepartments, including the bakers. Here, Russell is checking the dessert pies. Star Island was noted for its homemade breads and baked goods. Other kitchen departments included cooks, butter cutters, pot scrubbers, and dishwashers. The kitchen, besides preparing three meals a day for the conferees, also prepared three meals for the staff.

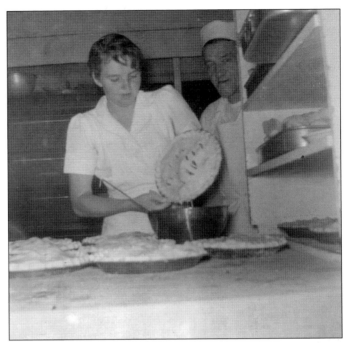

The last dinner of a conference was known as the banquet. This dinner was more formal than the other meals. After dessert was served, the kitchen staff was called out by the conferees, starting with the cheer "We want the cooks" and ending with "We want the waitresses." All this was done with big cheers for each group. Here, the Pelicans are taking their last bow.

Much of the success of the conference center on Star Island is from the contributions made by individuals such as Ed and Myrtle Donohue. For years, Ed was the person who serviced and repaired the refrigerators, and Myrtle planted and cared for the petunias along the walk from the pier to the hotel. This volunteer practice has a long tradition, and as one generation passes, another takes up the work.

Safe drinking water is essential for the conferences on Star Island. The old well could not handle the need. In the early 1960s, salt water converters were installed. Members of the board are inspecting the new condenser. In the 21st century, the boat to the island has a larger capacity to import freshwater. In current times, there is also a reverse osmosis apparatus on the island.

The importance of water to Star Island was evidenced by this display in the hotel lobby. Note the fire alarm in the background. Fire is another reason to have a reliable and ready supply of water.

Nancy Nevins worked as a Pelican at Star Island in the mid-1950s. She is seen here carrying a laundry basket as she approaches the clothesline. At times, laundry was done on island, but sometimes it sent off island or a combination of both, depending on the economics.

Star Island has been a place of innovation. Coming up with solutions for problems when one could not run to the hardware store inspired imagination. As a result, Pelicans and management gained knowledge and experience that they were able to apply to other areas of their lives. Note the clothesline on the truck.

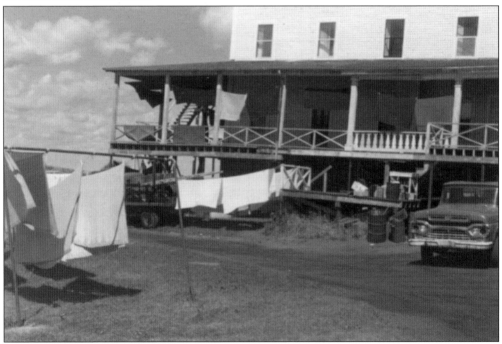

The truck clothesline is full, as is the regular clothesline, and there is still need for more places to put the sheets. Sheets are hanging on the side porch of the Atlantic House section of the hotel. Note the two columns with the old balustrades still left on the porch.

This is the back of the hotel. A need developed for a particular shape of steel, and it was made right on Star Island. A 55-gallon drum was cut in half and became the forge. Note the rocket-ship vacuum cleaner, which served as the bellows for the forge; the piece of metal is in the forge being heated so it can be shaped.

Red-hot, the piece of metal has been taken to the anvil to be shaped into a useful part for the Star Island physical plant.

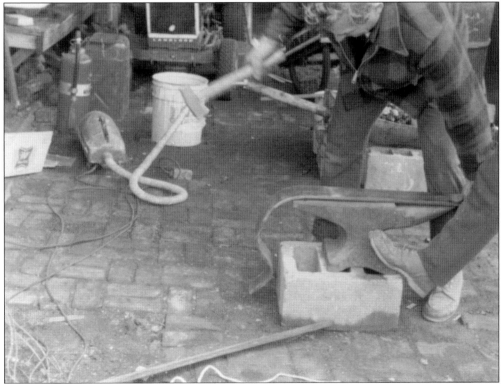

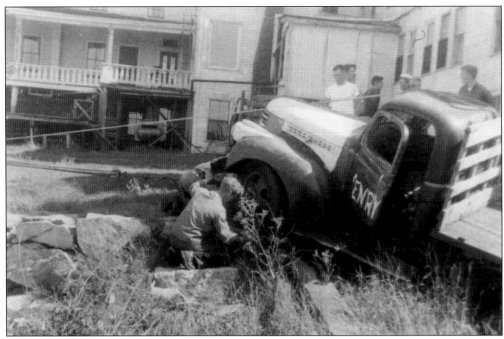

Things did not go smoothly every day. This truck, called "Enry," has gone over the rocks by the bridge known as the truck trestle. A small group has gathered, no doubt some of the truck crew. The question is how to get the truck back on the road. Note the two sections of balustrade on the porch rail on the side of the Atlantic House part of the hotel.

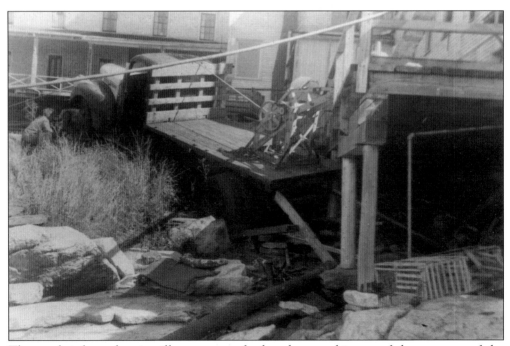

The truck is braced so it will not go any farther down or hit one of the supports of the truck trestle.

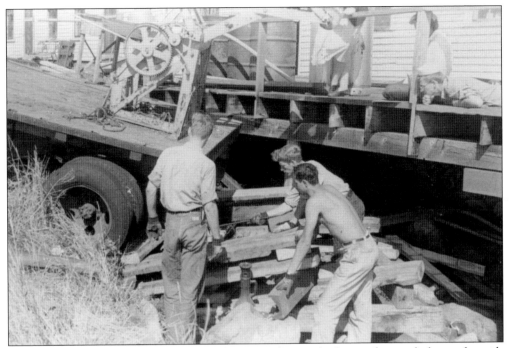

Two things have to happen; first, the truck cannot slip any farther, and second, the truck needs to be able to get some traction on its own or another vehicle has to be able to pull it out. There was no other photograph showing the truck on level ground; however, there is no reason not to think that the truck made it back to useful service.

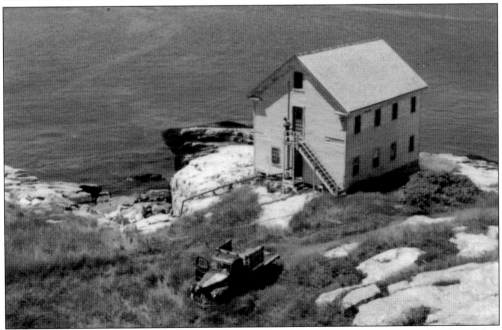

This is the same truck sitting in the high grass by the shack. It looks like it is abandoned, but perhaps it is not. Note the person at the top of the stairs with what appears to be a camera in his hand. The shack once housed a gas plant for the hotel and later became a dorm for Pelicans.

This was an icehouse for ice cut on the pond. The building became the site of the first generator for electrical power. In the early 1960s, a new utility building was constructed, replacing this building for the generators. Now, this structure serves as the art barn. The wooden barrel once on the tower on Appledore Island spent its last days rotting away here.

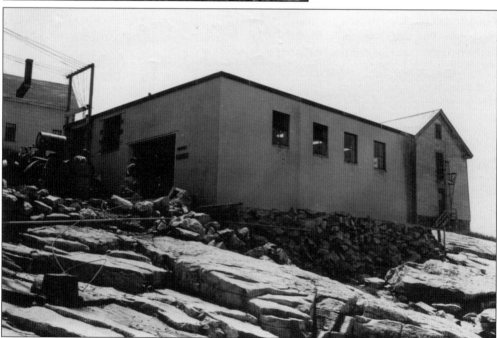

This is the utility building, constructed between 1960 and 1962. It replaced the art barn as the place for the diesel generator. This building also was the site of saltwater conversion. The overhead wires mounted on the front of the building have been either buried or cleverly hidden under porches in later times. The saltwater converters have been replaced by reverse osmosis installed under the hotel.

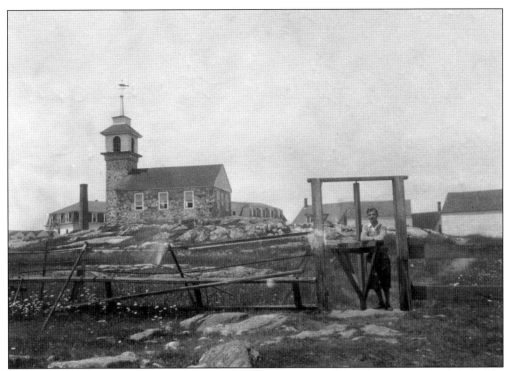

The turnstile was installed to allow a gate in the fence separating the people from the grazing animals. This photograph was taken in July 1925. The man standing at the turnstile is Kermit Houghton. The large chimney in the background is for the boiler, which was below the kitchen in the hotel and supplied all the heat and power to the island.

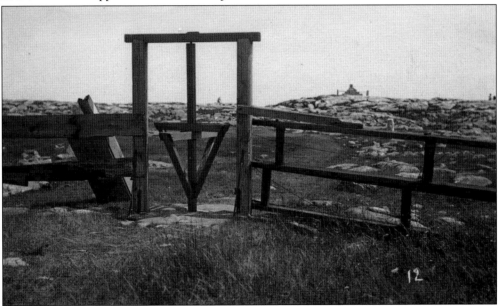

This photograph of the turnstile dates to the same period as the previous image, but the view is from the opposite direction. The monument to John Smith is in the background. Note the sparse vegetation.

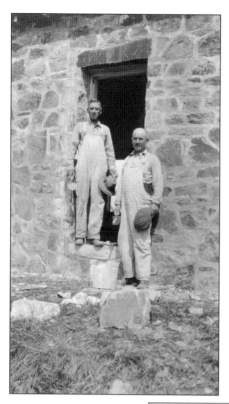

In 1927, the stone parsonage was built by volunteers, professional contractors, and two stonemasons. The man on the left is Thomas Taylor, a stonemason. His instructions were "to build a wall that would stand forever and be a pattern for any future stone work done on the Islands." The man on the right is Taylor's assistant, identified only by the name William.

The Tucke Parsonage is named after Rev. John Tucke (1702–1773), who served the town of Gosport. This building was constructed on old foundations sometime after 1780, when the previous building was moved to York, Maine. This parsonage burned in 1905, and the new stone parsonage was built on what was left of the old foundations.

The 1920s were good for Star Island. It became apparent that it was necessary to increase the capacity of the island. To reach this goal, the concept of recreating Gosport Village in stone was put forth. The stone parsonage of 1927 was the first of what were to be several stone buildings. The Great Depression and World War II put this plan on hold until after the war.

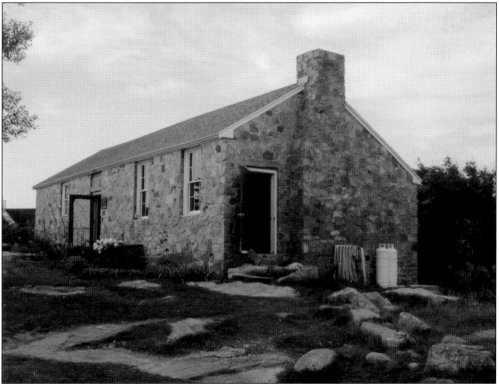

In 1948, the second stone building was erected, and it was named after Rev. Asa M. Parker, former president of Star Island Corporation. In 1953, Newton Center Parish House was built on the site of the Gosport schoolhouse. It is the largest of the stone buildings and named in honor of the Unitarian Church of Newton Center, Massachusetts, that donated funds for its construction. It is the only one with an ell.

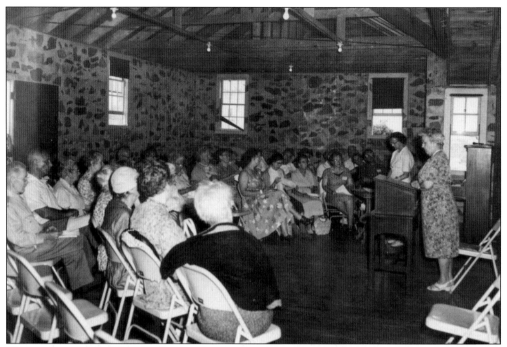

This is the inside of Newton Center during a conference meeting in the 1950s. This room has held up to 200 people for various meetings. On the left of the photograph is the front door. Behind the speaker, not pictured, is the second room of this building.

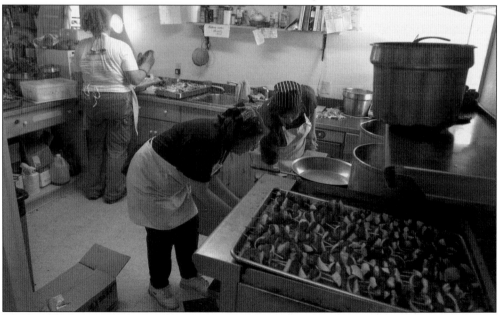

Until 1955, the second room in Newton Center served as a dormitory for youth. Fred McGill reports the arrangement was like an old Pullman car, with an aisle down the middle and green curtains for privacy. This arrangement stopped when the motel units were built. Here, the kitchen staff is preparing a meal for volunteers who have come to Star Island to help open up on Memorial Day in 2004.

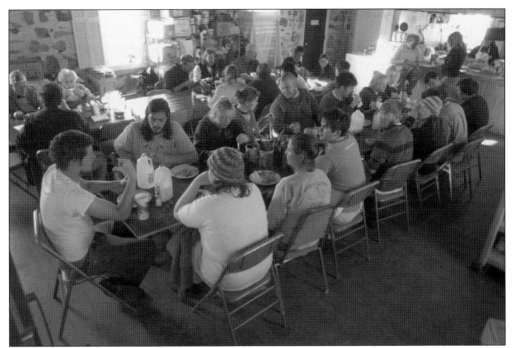

Memorial Day 2004 was a busy time for Newton Center. Here, the volunteers are enjoying a meal before they go to work. In the spring, many hours are spent to open up the facilities, and this flurry of activity is repeated in the fall for closing. Newton Center is the headquarters for these activities.

Marshman was built in 1998, in honor of Barbara Marshman, and was the last of the stone cottages to be constructed. It is used for meetings and various activities. In this photograph, a shadow of the chapel's tower, the first stone building, falls on Marshman, the last-built stone structure.

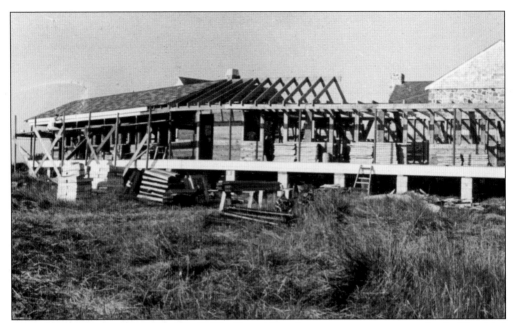

In 1946, Star Island opened after World War II, and Shoalers were anxious to come back. The third and fourth floors of the Oceanic were closed, a loss of 70 rooms. The solution was to build new rooms. William R. Greeley, an architect and president of the Star Island Corporation (1948–1954), designed new housing. The first two, Sprague and Founders, were built in 1953; Young People's Religious Union (YPRU) and Baker, in 1955.

This building has two distinct parts: the section on the left side is the Rutledge Marine Laboratory, and the section on the right is the Brookfield Center. This reflects the efforts to promote more awareness in the natural environment of the Shoals and provide more space for activities for young people and others. This building was constructed in 1971. (Courtesy of DJC.)

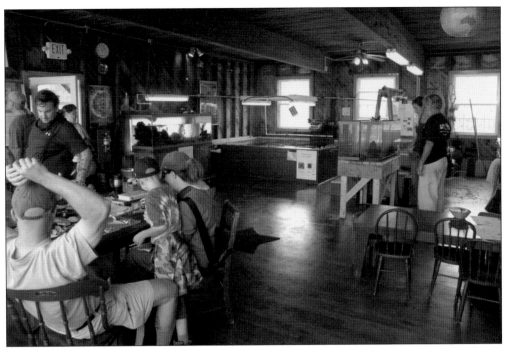

The marine laboratory offers programs for young and old. It also allows for drop-ins to see what is new in the lab or identify the bird to which a found feather belongs. Additionally, the lab offers nature programs around the island. (Courtesy of DJC.)

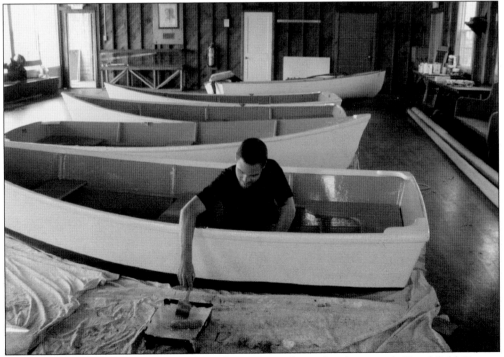

Dancing, yoga, and tai chi are not the only activities that take place inside Brookfield Center. Painting boats during spring "open up" often takes place there as well.

This is the interior of the carpenters' shop. All the woodworking projects not requiring a contractor are headquartered here. This may include restoring the hotel's antique furniture or building new furnishings. Note the cabinet doors with the various notes and work assignments. (Courtesy of DJC.)

The carpenters' shop is tucked between the utility building and the shack. In the photograph, one can see a traditional New England fishing dory. This was an after-hours project of Pelicans. Bonfires are one of the traditions on Star Island, and there is a ready supply of fuel at the carpenters' shop, as well as driftwood. There is also a paint shop and an engineers' shop. (Courtesy of DJC.)

On a cold spring day during "open up," the ramp from the pier to the float is being moved from its winter storage to the pier.

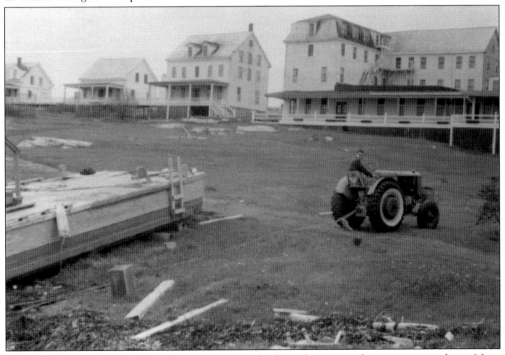

The floats for docking and swimming are going back in the water after a winter onshore. Note the old fire escape on the Gosport section of the hotel. A new enclosed fire escape was completed on the side of the building to bring the structure up to code.

A hotel that is made up of buildings that date from the 19th century needs constant care and repair. Often, repair and upgrading requires the service of contractors and some heavy equipment. Clapboard replacement, scraping, and painting on the back of the Oceanic and Caswell is just the type of project that merits a contractor. Note the open fire escape to the rear of the hotel.

On Star Island, luggage, laundry, supplies, and anything that comes off a boat or truck is passed along in a line. Sometimes, these lines may reach up three flights of stairs. The line in this photograph of staff unloading the truck is not a perfect example of the Star Island concept, which is for each person in line to pass items to whoever is opposite him or her. (Courtesy of DJC.)

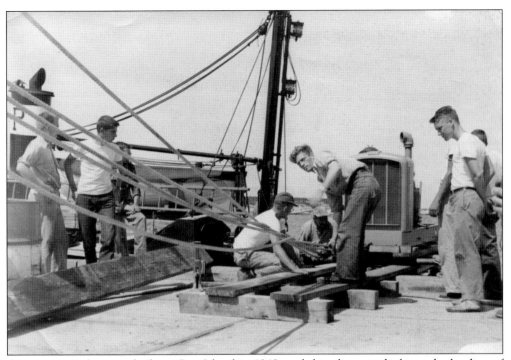

A new power plant was built on Star Island in 1948, and this photograph shows the landing of the diesel engine that was installed in the facility. Bringing the diesel out by tug was the easy part; getting it to the old icehouse was the hard part.

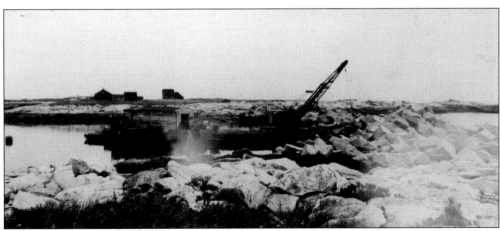

The breakwater between Smuttynose and Cedar Islands was rebuilt in 1904, and the breakwater between Star and Cedar Islands was built between 1913 and 1914. The federal government constructed both, and the breakwaters made Gosport Harbor much safer. Storms caused damage, and repairs had to be made. Some of the storms that impacted the region include the nor'easter of February 17, 1952, Hurricane Carol on August 30, 1954, and the blizzard of 1978.

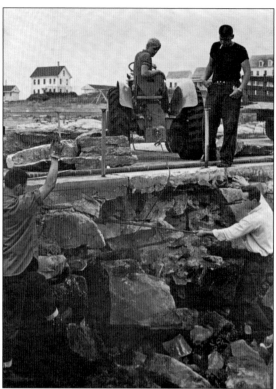

Lyman Rutledge, in his book *Ten Miles Out*, calls the nor'easter of February 17, 1952, the "tan toaster." This storm caused an eight-foot gap in the pier, but a temporary bridge was built over it. The estimate for repairs was $9,000, but Star Island performed them in-house for $6,000. Many more repairs, minor as well as major, have been made over the years. This photograph is of a 1963 repair.

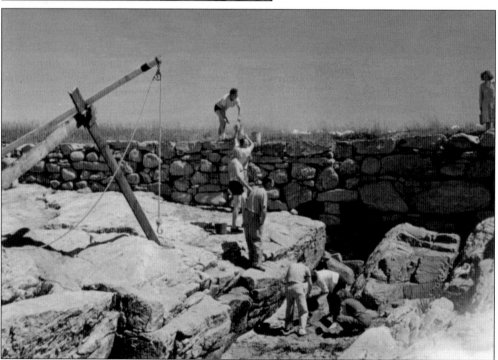

The sea and time take their toll on seawalls as well as the pier. Here, a repair is being made to the seawall at Star Island in the traditional manner—by staff and volunteers.

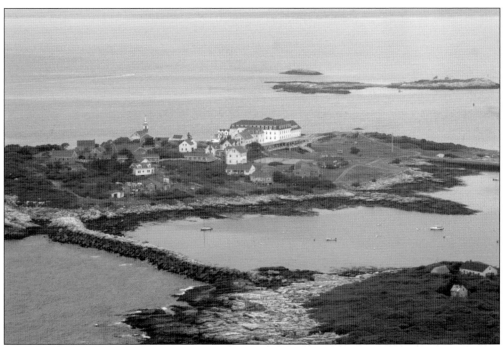

This aerial photograph provides an excellent view of the breakwater that connects Star and Cedar Islands, as well as most of the buildings on Star Island.

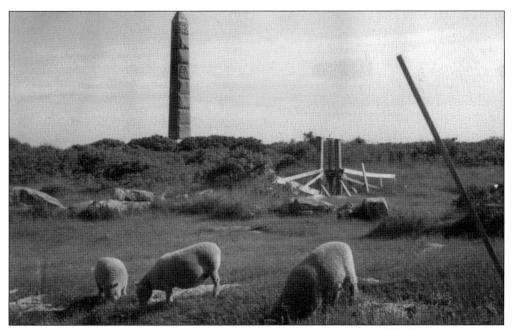

During the 20th century, livestock were employed to maintain the lawn. The idea was that sheep would keep the grass short during conference time and there would be a market for the sheep at the end of the season.

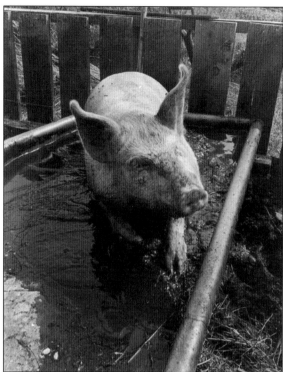

Star Island's food service produces a considerable amount of waste, which is a problem on an island. Composting and using kitchen waste as hog feed have been tried with varying success. This fellow went to market after a season on Star Island much fatter than when he arrived.

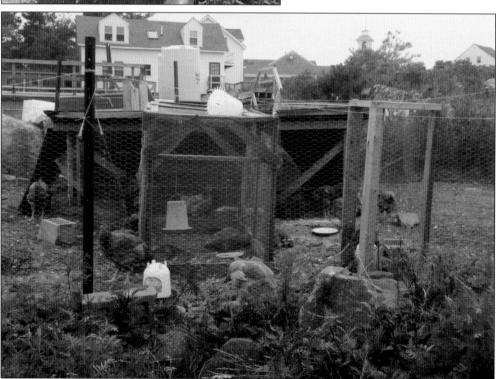

A more recent attempt to have livestock on Star Island is the chickens that supply eggs—not for the guests, but for Pelicans. (Courtesy of DJC.)

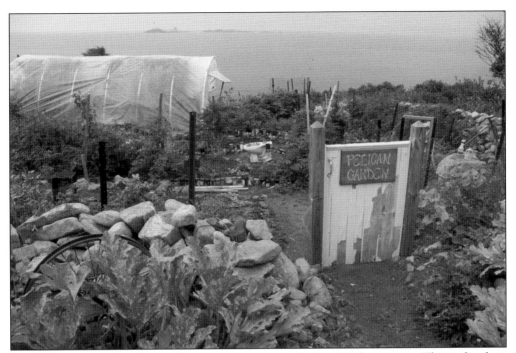

Pelicans have developed a garden using compost made from kitchen waste. This is for their consumption and not served to the guests. The garden has been in operation since 2001, and 548 pounds of produce were grown in 2012. (Courtesy of DJC.)

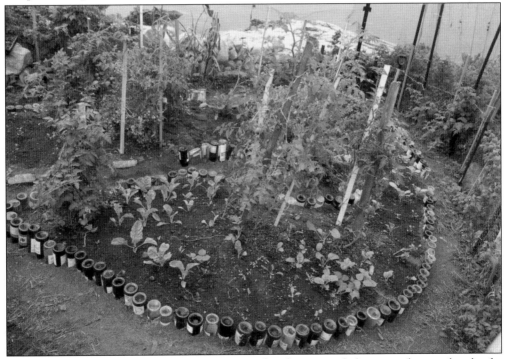

In this view of the Pelican garden, one can see they have recycled wine and spirits bottles for borders to their beds. Hopefully, this garden is successful for many years. (Courtesy of DJC.)

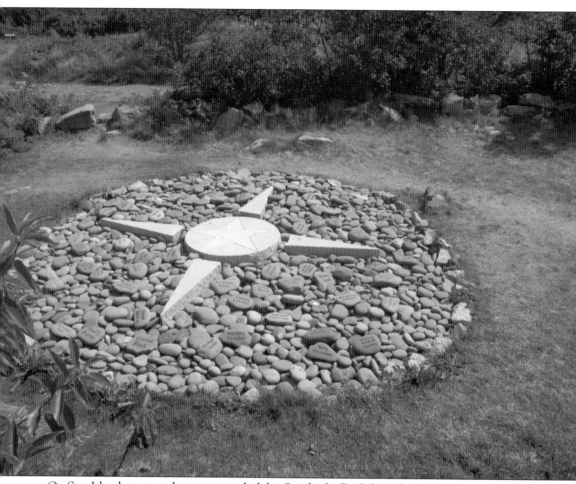

On Star Island, two men have memorials. John Smith, the English explorer who gave New England its name and named the Isles of Shoals for himself, has a monument on the east side of the island. Rev. John Tucke, the 18th-century minister who brought peace and order to Gosport villagers and served as their spiritual leader from 1732 to his death in 1773, has a large obelisk over his grave. There are some other grave markers, mostly of 19th-century inhabitants of the island. This recently dedicated star-shaped memorial honors members of the Star Island community who in their lives made contributions to the island and its mission. (Courtesy of DJC.)

Four

PELICANS AND PENGUINS

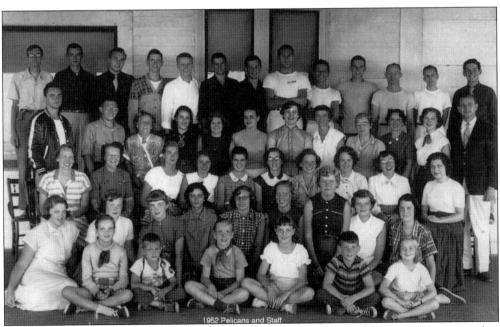

1952 Pelicans and Staff

Pelicans and Penguins are affectionate terms given to those who staff the various positions that keep Star Island operating as a conference center and island community. From providing hospitality services to managing the waste treatment plant, these "Star lights" have been essential ingredients to the success of Star Island Conference Center since the beginning. Shown here in 1952, the staff considers the annual group photographs as much a tradition as the conferences.

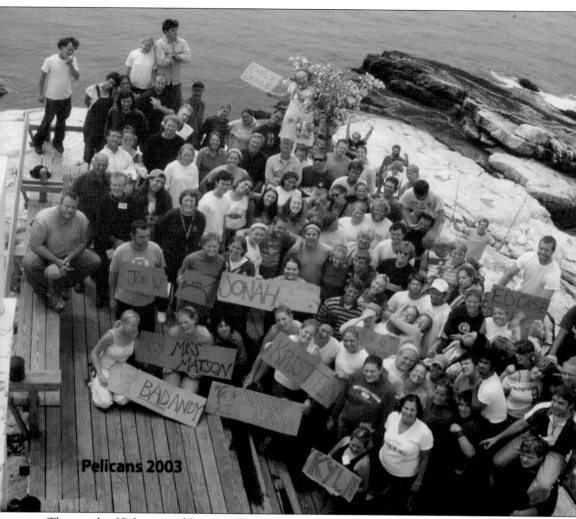

Pelicans 2003

Thousands of Pelicans and Penguins have come and gone over the years. For many, things will come full circle—from conferee as a child, to Pelican as a teen or college student, to Penguin (an older staff member) as an adult, to conferee once again as part of Pel Reunion Conference. It is virtually impossible to capture more than an infinitesimal fraction of life and times through the years. This chapter humbly highlights some Pel traditions and often candid shots of Pels at work and play. Here is what is known as the "Pel Photo" for the 2003 season. Note those unable to be present for this special annual photograph are represented with signs held by their coworkers and comrades.

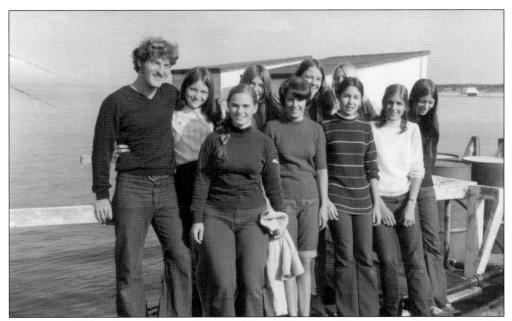

One former Pel recalls that the social norms of the 1960s dictated that certain sexes were hired for certain jobs. Only females waited tables, and they were referred to as waitresses. Chambermaids were responsible for all housekeeping duties. Later, both males and females held these positions, and they were referred to as "waitrae" and "chamber." A smiling group in the undated photograph above poses for the camera on the Star Island pier. The photograph is labeled "Chambermaids and laundry Pelicans." Below is an image of laundry hanging on the clothesline behind the Oceanic Hotel. If this were a color photograph, one would see how the tradition stands that the laundry be hung grouped by like colors.

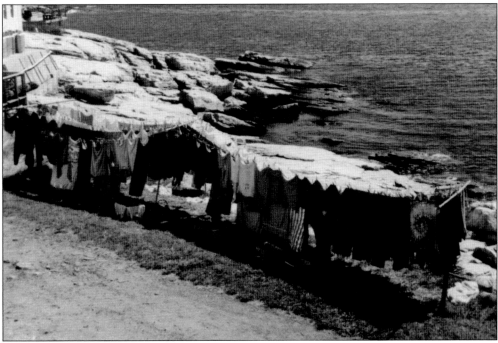

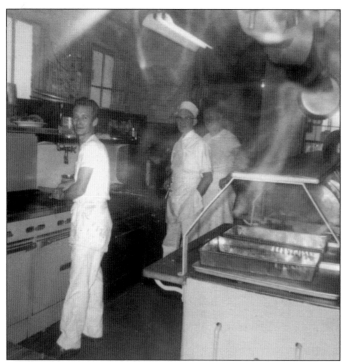

Shown here are three Pels preparing a meal in the kitchen of the Oceanic Hotel. The inscription on the back of the photograph reads, "Lloyd, Lenny and Dick cooking for Pel Banquet, August 31, 1968." Pel Banquet was originally held at the end of the season, when the last of the conferees had departed.

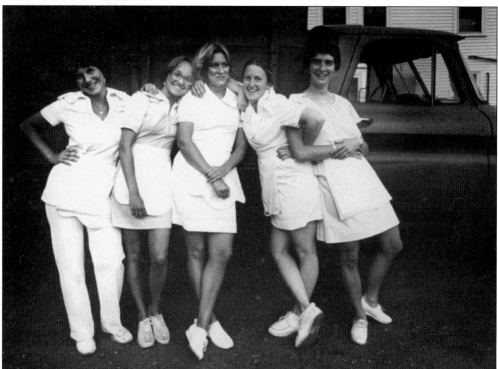

This photograph was taken in July 1977; the group pictured, by that time referred to as "waitrae," poses in front of an old workhorse island truck that is parked in the rear of the Oceanic Hotel. Note the white uniforms and shoes—not required for the job today.

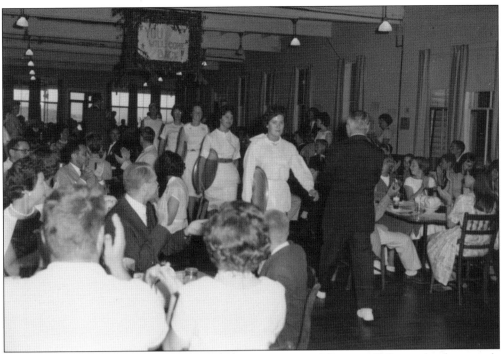

The weekly conference banquet night includes recognition of the many Pelicans that have made the evening's meal possible. There are waiters and waitresses, butter cutters, bakers, and more. The tradition calls for conferees to call out and chant for those manning each station until they emerge from the kitchen and parade down the center of the dining room to an eruption of applause. Above is a photograph from a conference banquet night in 1962. Note how the ritual is carried out in a fairly formal fashion. Below is a more recent image of the same tradition.

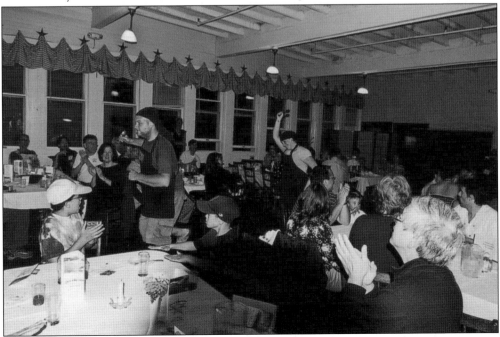

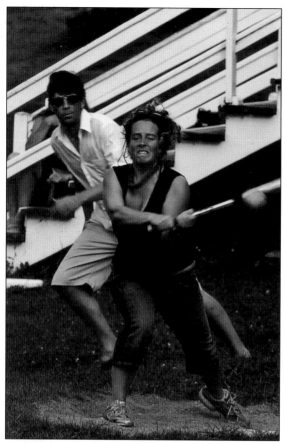

The weekly softball game between Pelicans and conferees is definitely a competitive event, as the image on the left confirms. Some may be under the false impression that it is part of a Pelican's paid job to participate in the weekly softball game. As with Pel Show, participation is encouraged but completely voluntary. The Pelicans that participate do so of their own accord for the sheer enjoyment of it. Part of their Pel Club dues are spent on team uniforms. Below, a group of Pelicans plans its strategy in summer 2008. The team members are, from left to right, Jeff Whitehead, Tom Reid, Amy Meek, Drew Parsons, Chris Tourloukis, Marshall Frye, "Tall Tom" McCarran, unidentified, Jeremy Parker, William Dahab, Keith Oshel, Nick Tourloukis, and Noah Blakney.

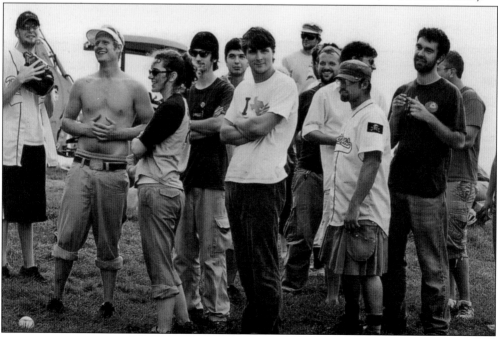

Pel Show is certainly one of the most anticipated conference events of the week. Typically held mid-conference, it was conceptualized in the late 1940s by music director John Woodworth. The amazing and varying talent of individual Pelicans is showcased. Group performances featuring barbershop quartets, comedic skits, and choral numbers abound. Solo performances such as magic shows, classical instrumentals, and musical renditions of all sorts— the talent is seemingly endless. Pel participation in this event is also completely voluntary. The image on the right shows Pelicans performing for All Star Conference 1967. Below, Pels record their weekly chorus concert.

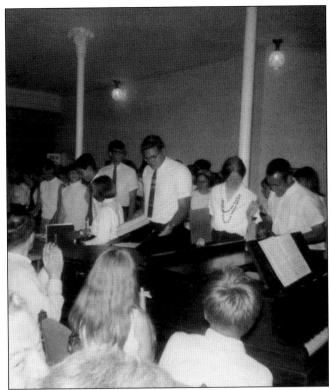

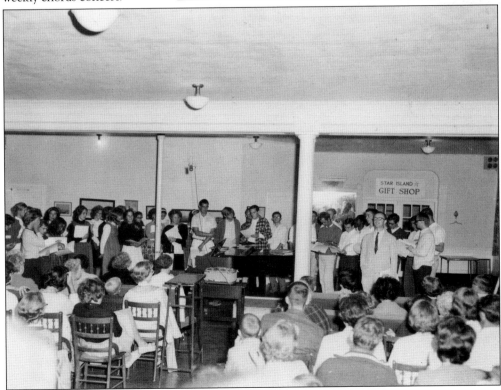

Fire is a serious matter on Star Island, as many of the buildings date from the 19th century. Fire prevention needs to be a communal effort, so cooperation of the entire island community is key. Pelicans are the first line of fire prevention and are trained in responding to all fire alarms. They take turns on fire watch, which means that even when they are off duty from their regular job they are on call in case of fire alarm.

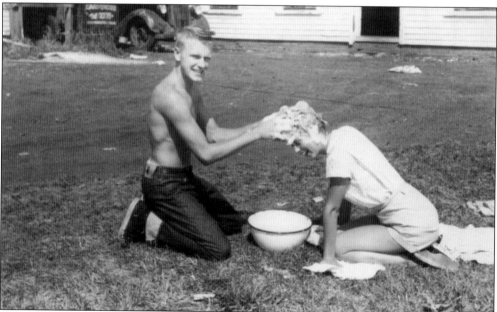

The island has gone from a bucket brigade to sprinkler systems and fire extinguishers. The days of open flames allowed in guest and Pelican quarters are over. And although water still needs to be conserved on the island, one does not often see Pels washing each others' hair utilizing a bowl of water. Pictured here in the 1950s, night watchman Dick Perry lathers up a comrade's tresses by the clothesline in back of the Oceanic Hotel.

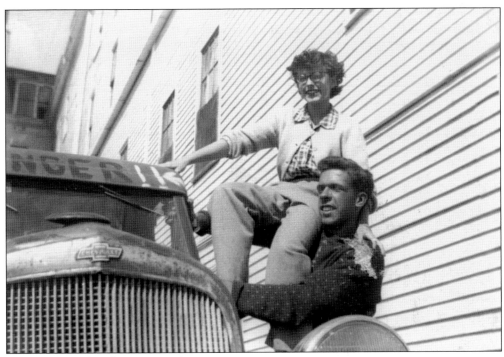

One wonders what shenanigans these two Pels are up to in this photograph from the 1950s. It was taken near what is known as the truck trestle. The young man appears to be lifting the damsel up onto the roof of the old Chevrolet truck. The Pelican on the right is precariously perched atop a crane of sorts near the end of the pier. Perhaps he is awaiting further instruction from his supervisor. Or maybe he is simply taking a break from the workday.

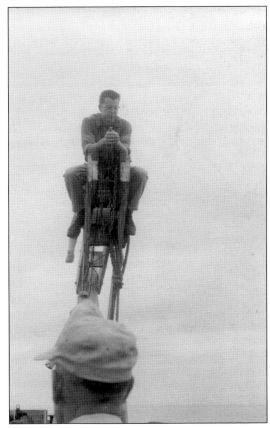

Although they are dedicated and work hard, not all is toil for the Pelican. There is still time to enjoy the islands, each other, and the unique experience that is Star Island. For example, if rowboats belonging to Star Island are available down at the dock, Pelicans are welcome to sign them out and go for a row around the harbor. Perhaps these young people from the 1950s are about to row across the harbor to nearby Smuttynose Island.

Fishing, once a vital source of income, is another pastime enjoyed by Shoalers, be they conferees or Pelicans. One often sees schools of bluefish feeding on the surface of the water. Here, in the 1950s, Dana Frost (foreground), son of the island manager at the time, and his friend Robert are about to try their luck at fishing in the harbor. (Courtesy of Sara Frost Schoman.)

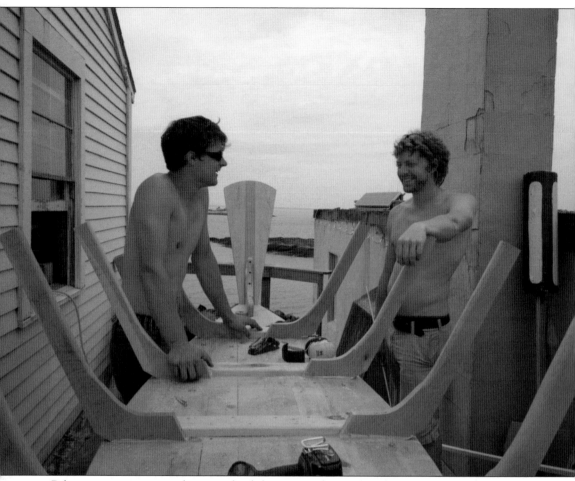

Pelicans are inventive and creative by definition, and many are also resourceful and skilled. Star Island is a place where they can pursue their interests and also share their gifts with each other. In 2007, Star Island Conference Center had a delay in opening for the season. In a positive response to the situation, Pelicans used the opportunity to start the Gosport Town School. The idea was to create an informal program through which Pels could teach other Pels their unique skills and talents. It is still in existence today. This photograph was taken in 2012. Island engineer Marshall Frye (left) and buildings manager Johnny Kadlik spent their off-duty hours building a replica of a Banks dory once used on the islands. (Courtesy of Annaliese Reutemann.)

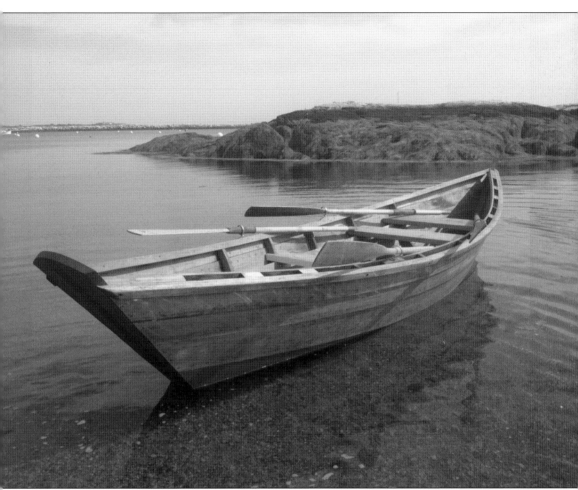

Anything seems possible on Star Island. Given the men's combined skills of engineering and construction, boatbuilding seemed a reasonable venture. Frye and Kadlik spent hundreds of off-duty hours crafting the dory, and their tenacity paid off. The dory was launched on October 8, 2012, and christened the *Jolly Beggar*—it floated. This Banks dory, crafted on Star Island by Pelicans Frye and Kadlik in their spare time, is featured in the January 2014 issue of *Wooden Boat Magazine*. (Courtesy of Annaliese Reutemann.)

It would be amiss to talk about Penguins and Pelicans and not mention Lyman Rutledge. Considered the island historian of his era, he penned the well-researched book *Isles of Shoals in Lore and Legend*. Rutledge led a secret society of sunrise watchers dubbed the Dawn Birds. With his countless contributions and dedication to Star Island still vivid in Shoalers memories, a moving service was held for Rutledge in August 2012 at which a special rock was placed facing east in the memorial garden. The image on the left shows Rutledge giving the Cook's Tour of the island to a group. Below, his son Edward is fishing as a young boy with the Oceanic Hotel in the background.

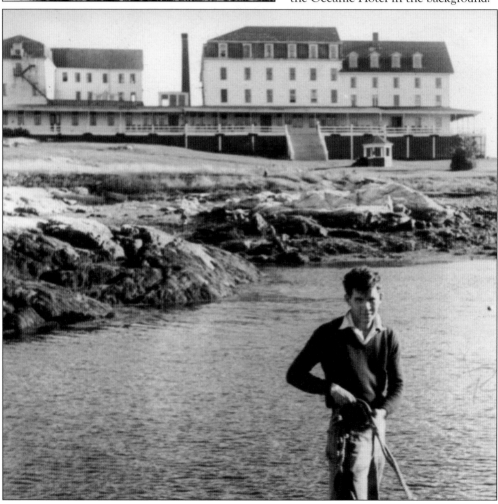

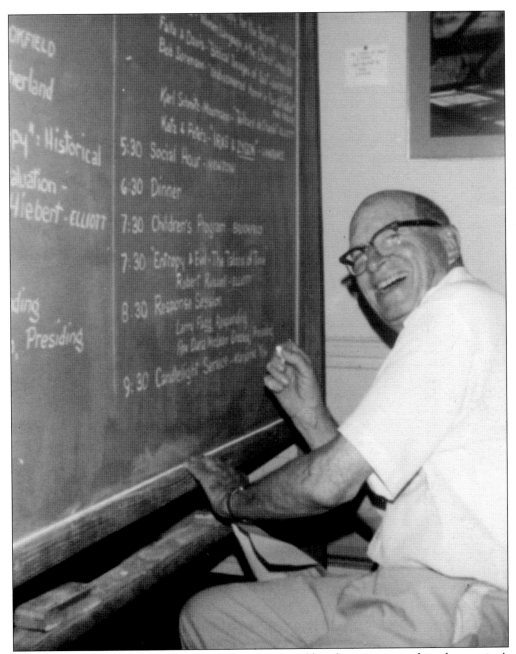

Here is a candid shot of a laughing Fred McGill as he adds information regarding the evening's candlelight service to the lobby blackboard. McGill first stepped foot on Star Island in 1922 as an 18-year-old Young People's Religious Union (YPRU) conferee. For the next 70 years, McGill was a fixture on Star Island, even during his last year of life at age 98. He served in many capacities over the decades—historian and storyteller are but two. McGill's book *Something Like a Star* is filled with tales of life on Star Island from conferee, Pelican, and Penguin perspectives. Many fondly remember being greeted by McGill at the top of the stairs on the porch of the Oceanic Hotel upon arrival.

Carl Witherell was the president of the Isles of Shoals Summer Meetings Association from 1918 to 1922. He was later president of Star Island Corporation from 1938 to 1944. Witherell successfully chaired the campaign committee that was established in 1915. Its purpose was to raise $40,000 for the purchase of Star Island, necessary repairs, and a boat for transportation. The goal was surpassed, and a total of $45,484.21 was raised. Here, Witherell is dressed for a costume ball game in the 1930s.

This photograph of YPRU conferees Roland Greeley (left) and Ruey Packard was taken in the 1920s. Later a professor at MIT, Greeley was a local icon in his native community of Lexington, Massachusetts, and known as a leader at Star Island as well. He and others were instrumental in the effort to restore the chapel during the 1950s. In a letter to manager Tony Codding, Greeley relates the following story pertaining to a tragedy at the Shoals in 1902: "Uncle and some other Shoalers had been out with Capt. Miles just previously, but had prevailed upon him to take him in because of the blustery wind and threatening sky. When the band of waitresses, who were waiting for the next trip, expressed the desire to go, anyway, the returning party, including my uncle, warned them not to, and urged Capt. Miles not to go. He went nevertheless, ignoring their warnings and the threatening weather. My uncle never returned to the Shoals."

On the left is island engineer and heartthrob by all accounts Bobby Wharem. On Star Island in 1956, Wharem saved the life of 17-year-old Charles Evan. Evan, who could not swim, was attending the Camp Farthest Out Conference that year. While on the eastern side of the island, Evan either slipped or was swept into the water. Wharem's quick response saved Evan's life and earned him a Carnegie Medal for his heroism. The photograph below was taken in the 1950s. It shows manager Robert Frost and his daughter Sara. The Frost family was in residence on Star Island when Hurricane Carol hit the island in August 1954. In Vaughn Cottage's Hildreth Frost Collection, Frost provides a detailed written account of events of that day. (Below, courtesy of Sara Frost Schoman.)

Among those who have served as manager on Star Island during the conference years in the 1900s are many familiar names to some. Ed Pray, Bob Frost, Harry Lent, Steve Gardner, Pete Mercer, and Jim Smith are just a few that come to mind. Pictured at right is Bob Jorgenson, manager in the 1970s. Below is manager Churchill posing with "Pop the Baker."

Star Island's buildings and grounds must be maintained during the winter months. The position of winter keeper at Star Island can prove a lonely and difficult job, as it must have been during the northeastern blizzards of 1978 and 1991. But it can also be inspirational. The current winter keeper has produced art and literature that highlight the stark beauty that is Star Island in winter. Above are former winter keepers Edith and Dave Pierson, who held the position for 20 years. Below is an endearing image of devoted couple and Shoalers Edith and Albert Doolittle. Some may remember the pleasure of their first peek at the Star Island sky through Albert's famed telescope.

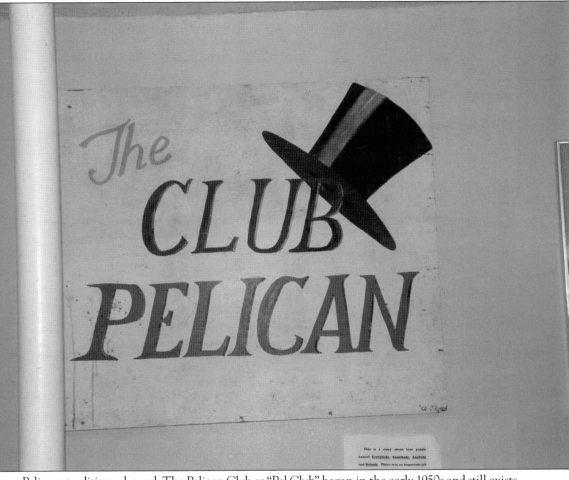

Pelicans traditions abound. The Pelican Club or "Pel Club" began in the early 1950s and still exists today. Some other traditions one can recall are *Pel Papers*—the annual publication chronicling the season's doings—and Pier Party. Not all traditions stand the test of time, however. Those who have had the pleasure of experiencing Pier Party, for example, surely lament its passing. In the 24-hour absence of a conference, the island belonged to Pelicans. Imagine this evening! Laity Weekend Conference ends, and all Pelicans fill the pier for the traditional Star Island send-off—with the exception of those staying behind to raise the pirate flag on the flagpole of the front lawn. Once the boat safely clears the pier and pulls away, Pels jump off the end of the pier and into the ocean below in various stages of undress.

One wonders if these two Pelicans in the 1950s are up to Pier Party shenanigans. After a brisk dip, it is back to quarters to shower and dress then back to the pier for cocktails and hors d'oeuvres and a sunset cruise around all nine islands aboard the vessel *Oceanic*. The captain maneuvers as close to Duck Island as possible and hovers there for awhile to allow passengers to watch the seals dive in and out, some curiously approaching to inspect the vessel. After an hour-long cruise, it is time to return to Star Island for Pel Banquet, served by upper management and perhaps even a board member. A fabulous entrée of honey-and-lemon-glazed salmon is served. Everything is gourmet, and bottles of wine are on every table.

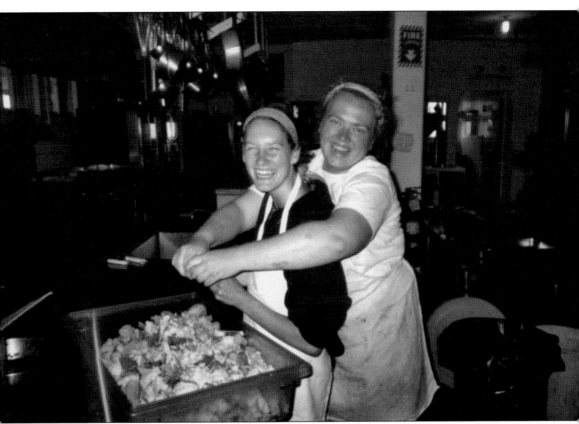

These happy kitchen workers are preparing dinner for conferees. But, on Pier Party night, dinner is prepared for them. Dessert is luscious, and a band begins to play in the festively decorated lobby. Cocktails of choice are allowed to be consumed right there in the lobby. Dancing ensues, of course. A group of students from Russia is employed at Star Island. A young man named Dinar, quite popular with the staff, takes to the dance floor. The crowd parts, encircles him, and chants "Go, Dinar! Go, Dinar!" as he proudly boogies around the dance floor.

Many "Star lights"—
Shoalers who have
contributed much to the
island over the years—
have come and gone.
But, the island could not
run without the beloved
Pelicans. On the left, a
group of these comrades
gathers on East Rock
in 1968. Below, a group
of Pelicans reluctantly
departs from Star
Island for the season
on September 3, 1972.
They laugh and wave
as they return the
traditional cheer, "R-A-
T-S, we *will* come back,
we *will* come back!"

Five

ODDS AND ENDS

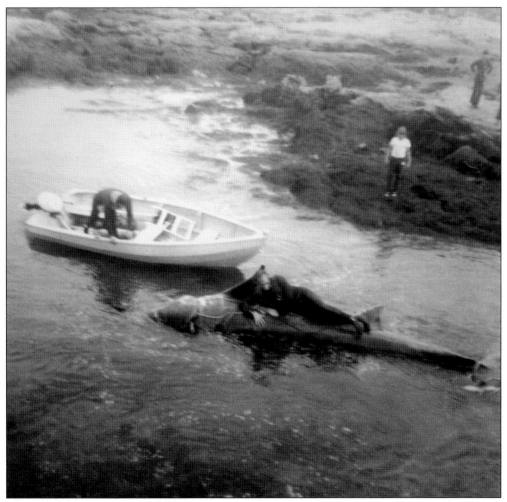

This chapter contains an assortment of interesting and rarely seen images related to Star Island. Here, a man poses atop a basking shark in the swimming area at Star Island during the All Star Conference of 1972. The carcass was found floating in Gosport Harbor, and a group of men towed it to shore for this photo opportunity. It measured 19 feet in length. With a rather large seal population on nearby Duck Island, shark species do frequent the area waters. One species of fish commonly found in the Gulf of Maine is the mackerel or porbeagle, which is often confused with the mako shark.

Ed Harker of Fairhaven, Massachusetts, is holding a six-pound sand shark he caught with his bare hands. During the Religious Education Institute conference in July 1963, Harker was enjoying an afternoon hike over the rocks when he spied the fish. He was able to reach down and grab the shark before it slipped away into the waters, surely impressing his comrades. The photograph appeared in Fairhaven's *Phoenix Press.*

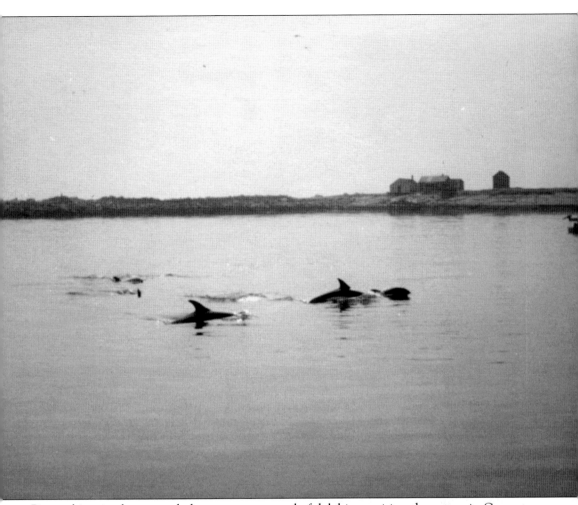

Pictured is a rarely captured phenomenon—a pod of dolphins cruising the waters in Gosport Harbor, photographed in August 1972. Cedar Island is visible in the background.

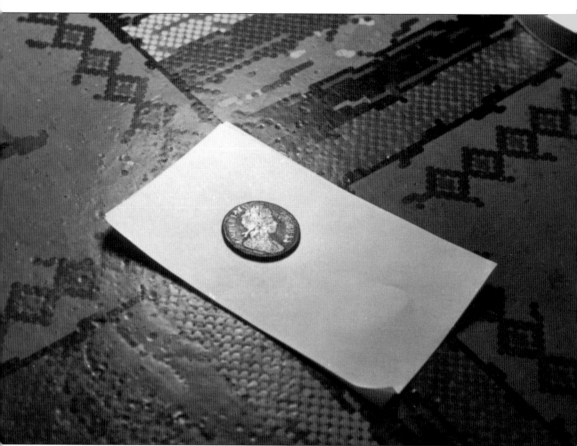

Many believe that pirates frequented the Isles of Shoals during the 17th and 18th centuries. During the 1950s, treasure hunters corresponded with Star Island Corporation regarding a new technology they used to locate what they believed might be pirate treasure on the east side of the island. They provided an aerial photograph revealing what appeared to be an object of metallic composition deep within the ground. Although the corporation considered granting rights to excavate, negotiations were unsuccessful, and excavation was denied. On August 20, 1957, this coin dated 1699—whether originally belonging to pirate or islander—was discovered on Star Island by a conferee.

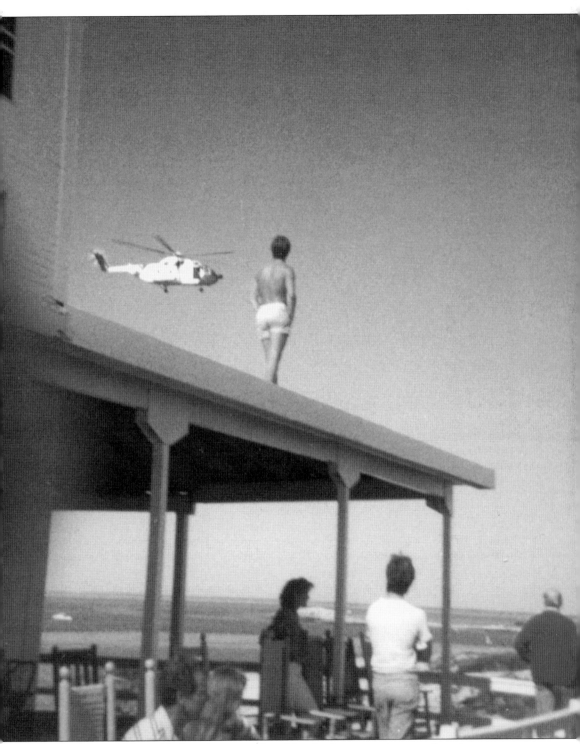

This image would be unlikely today given Star Island's close attention to safety. A young man stands on the west end of the roof of the Oceanic Hotel porch as a US Coast Guard helicopter lands on the front lawn, probably to transport a sick or injured person to the mainland.

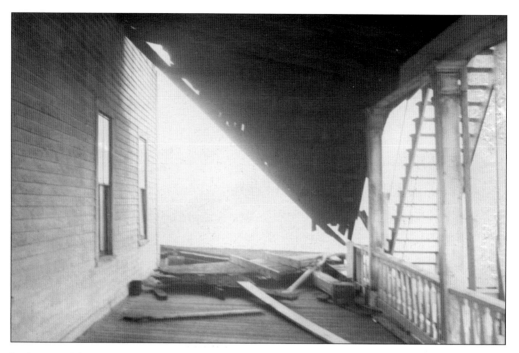

In August 1954, Hurricane Carol ripped across New England, causing 65 fatalities and horrendous damage. Because it was before the days of telephones, CB radios, or even homing pigeons on Star Island, there was little warning for Camp Farthest Out conferees and others on the island at the time. The hurricane-force winds hit Star Island quite unexpectedly. These images, photographed the following day, show extensive damage to island structures. The southwest end of the Oceanic Hotel porch, shown above, was demolished. The summerhouse, shown below, was completely destroyed. It was rebuilt by Pelicans the following season. (Both, courtesy of Sara Frost Schoman.)

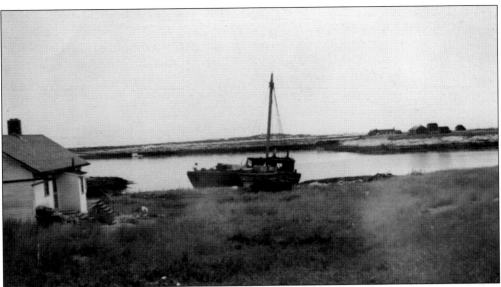

Before Hurricane Carol hit Star Island, the breakwater between Star and Cedar Islands was already under repair. A crane perched atop this seawall was toppled into the southeast end of the harbor by hurricane-force winds. Shown here in 1954 is an image of a US Navy barge washed up on the rocks in the southeast corner of Star Island, near Doctor's Cottage—quite probably the barge that transported that crane to the island.

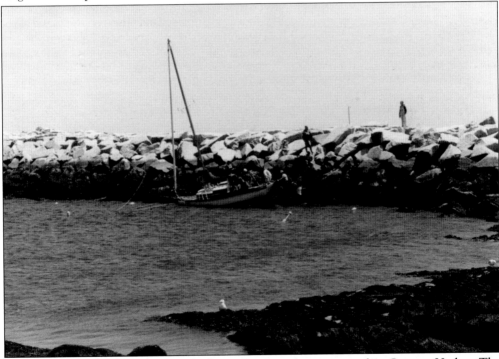

During the 1986 Arts Conference, the boat *Ganymeade* was moored in Gosport Harbor. The mooring gave way, and the boat went aground near the breakwater between Star and Cedar Islands. Those seen here include owners Nans and Dick Case Sr. attending to the situation. Dick is on board, and Nans is on the breakwater.

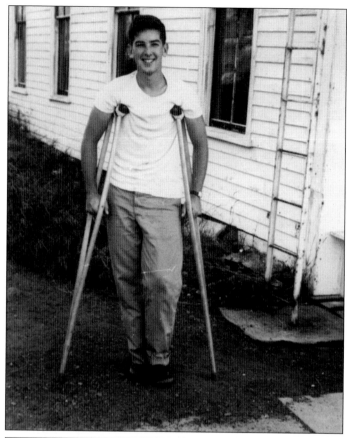

There have been many eyewitness accounts of rogue waves at the southern tip of Star Island. Probably the most well-known is that of the young teacher, a Miss Underhill, who was swept out to sea in 1848. Some believe this phenomenon is due to the geology of the ocean floor off the southernmost tip of the island. Pelican John Hobbs was first cook during the 1950s. He is shown here on crutches after his own encounter with a rogue wave while on the rocks near what is known as Lover's Cave. Below is an image of a US Coast Guard helicopter searching the waters off this end of the island for survivors of yet another encounter with a rogue wave in 1976.

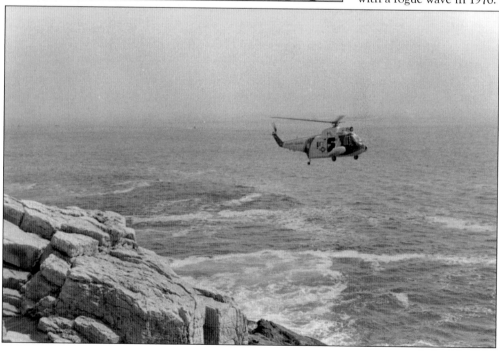

The image on the right is of a rogue wave of a different sort. This amazing photograph was taken in the 1970s and captures a wave formed of snow frozen in midair on the east end of the Oceanic Hotel porch. Imagine the photographer's surprise at stumbling upon this strange spectacle. Below is a rarely seen winter scene, taken in the 1940s. At this time, the parsonage was the only building in what is known today as the stone village. Note the starkness of the image and the lack of vegetation around the Tucke Monument. Also of note are the power lines—not seen today.

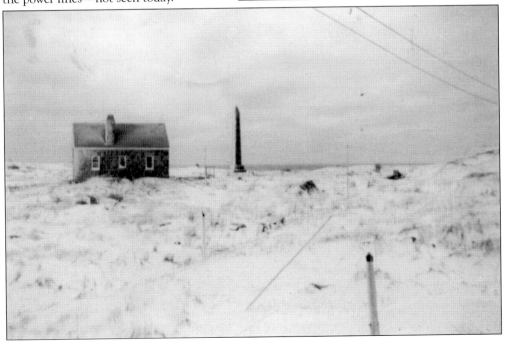

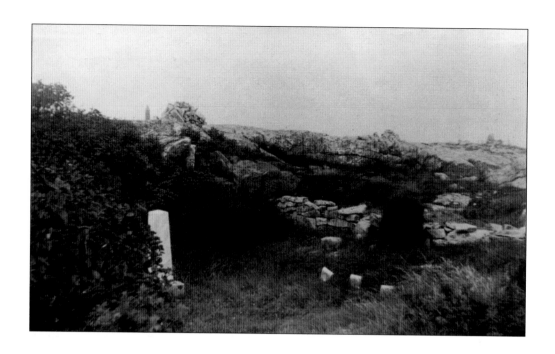

The image above is of Beebe Cemetery, a popular destination for Star Island visitors. Located in this hollow beyond the Tucke Monument are three tiny gravestones marking the resting place of young sisters Mittie, Millie, and Jessie, all victims of an infectious disease in the 1860s. If one descends into this low spot and peeks through the brush to the left of the grave markers, a carved stone embedded into the rock is visible. The inscription reads "Dudley Moore 1901– 1937." This memorial stone was most likely more conspicuous before this end of the island became overgrown with vegetation. (Below, courtesy of Marshall Frye.)

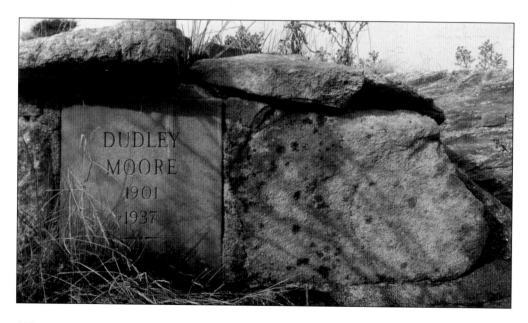

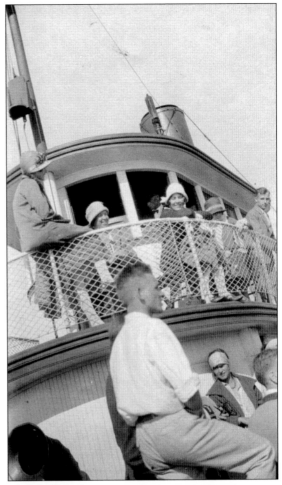

The back of the 1930s photograph on the right is inscribed "D. Moore." One wonders if the young man in the foreground might be the Dudley Moore memorialized in the aforementioned stone. Below is an image of a gravestone for Wilbert Haley. Haley was a local fisherman who provided fish for the Oceanic Hotel. The grave is located to the right along the path leading to Tucke Monument. This area is believed to be a cemetery of sorts for many of the early residents of the town of Gosport at Star Island. Although burials on the island are not usually allowed, Star Island Corporation made an exception in 1936 for this Gosport native who lies near his mother's grave. (Below, courtesy of Nate Trachimowicz.)

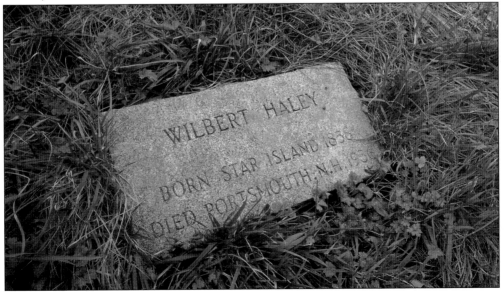

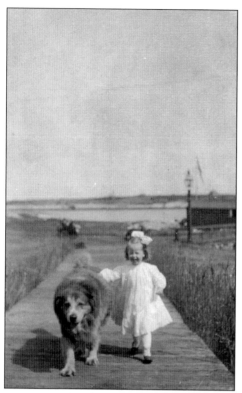

In the image on the left, little Elizabeth Ramsdell and dog Jack are happily strolling up a boardwalk leading to the Oceanic Hotel in 1907. Note the lamppost in the background. Neither the boardwalk nor the lamppost exists today. The image below was taken from Star Island as the USS *Kearsarge* passed behind White and Seavey Islands in the late 1800s. The inscription on the back of the photograph reads, "her last cruise . . . she was wrecked on Roncador Reef on this trip." The USS *Kearsarge* was built at Portsmouth Naval Yard in 1861 and commissioned in 1862. She was engaged in one of the Civil War's most memorable naval battles, near Cherbourg, France, where she sank the Confederate raider ship CSS *Alabama*.

Six

MORE ABOUT BOATS

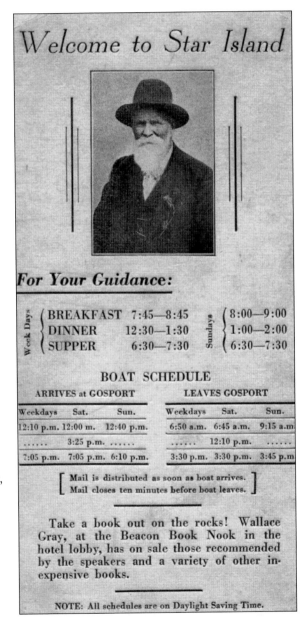

The boats that serviced Star and Appledore Islands in the 19th century, with few exceptions, were engine powered. This business was seasonal in nature. It is difficult to maintain a year-round service, considering the village of Gosport's population was small and after the hotel and conference season was over, there was no need for service. This boat schedule is typical of the time.

Welcome to Star Island

For Your Guidance:

Week Days {
BREAKFAST 7:45—8:45
DINNER 12:30—1:30
SUPPER 6:30—7:30
}

Sundays {
8:00—9:00
1:00—2:00
6:30—7:30
}

BOAT SCHEDULE

ARRIVES at GOSPORT			LEAVES GOSPORT		
Weekdays	Sat.	Sun.	Weekdays	Sat.	Sun.
12:10 p.m.	12:00 m.	12:40 p.m.	6:50 a.m.	6:45 a.m.	9:15 a.m
......	3:25 p.m.	12:10 p.m.
7:05 p.m.	7:05 p.m.	6:10 p.m.	3:30 p.m.	3:30 p.m.	3:45 p.m

[Mail is distributed as soon as boat arrives.
Mail closes ten minutes before boat leaves.]

Take a book out on the rocks! Wallace Gray, at the Beacon Book Nook in the hotel lobby, has on sale those recommended by the speakers and a variety of other inexpensive books.

NOTE: All schedules are on Daylight Saving Time.

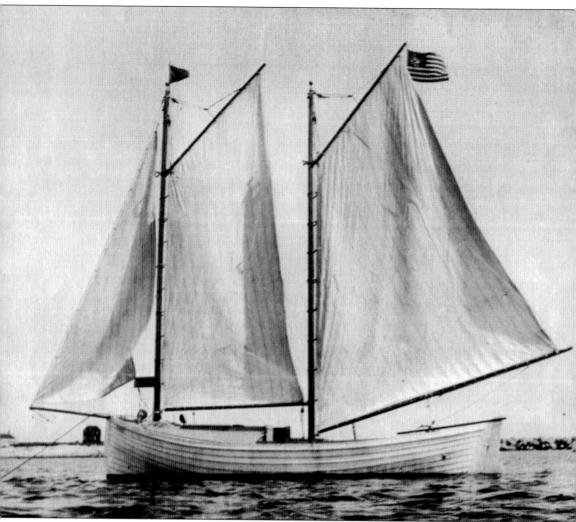

Howard Chapelle, in his book on American sailing craft, describes a small craft known as the Isle of Shoals boat. The boat was popular in the post–Civil War period, for fishing. When the hotels were open, these boats became party boats, taking guests on excursions. This sailboat was photographed in the 20th century in Gosport Harbor and may be one of the last sailing boats of this type.

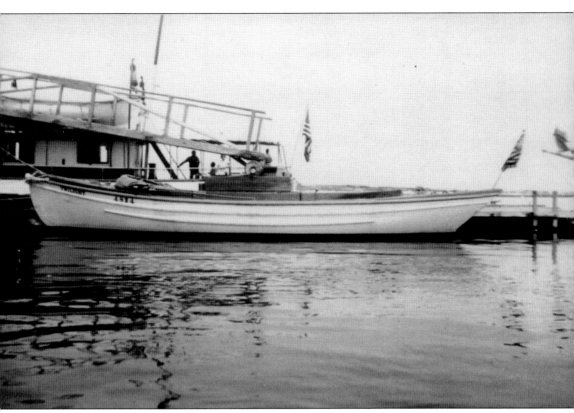

In the first decade of the 20th century, gasoline engines started to replace sails on small boats. The pleasure trips in and around the Isles of Shoals were still popular with hotel guests and conferees. Uncle Oscar Laighton's boat, the *Twilight,* is a good example.

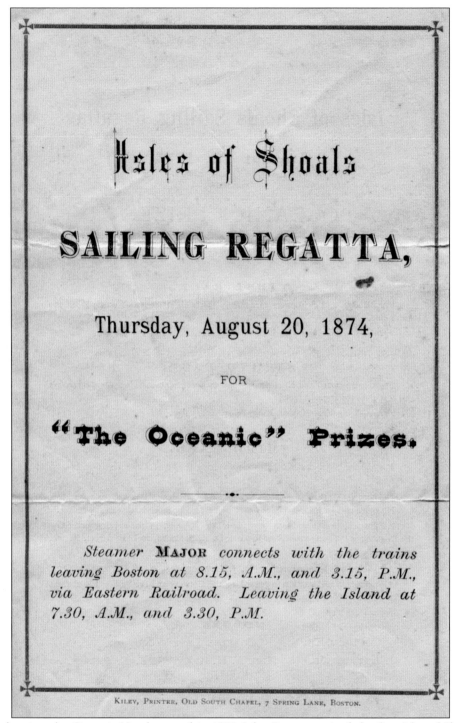

Isles of Shoals

SAILING REGATTA,

Thursday, August 20, 1874,

FOR

"The Oceanic" Prizes.

Steamer **MAJOR** *connects with the trains leaving Boston at 8.15, A.M., and 3.15, P.M., via Eastern Railroad. Leaving the Island at 7.30, A.M., and 3.30, P.M.*

KILEY, PRINTER, OLD SOUTH CHAPEL, 7 SPRING LANE, BOSTON.

At the time the Oceanic Hotel opened in 1873, John Poor organized the first Isles of Shoals Regatta. This event ran for three years. Uncle Oscar Laighton said of the first regatta, "This yacht race brought such a rough crowd here that it did Poor more harm than good. They even had fights over there." In 2010, the Gosport Regatta was reestablished as an annual event.

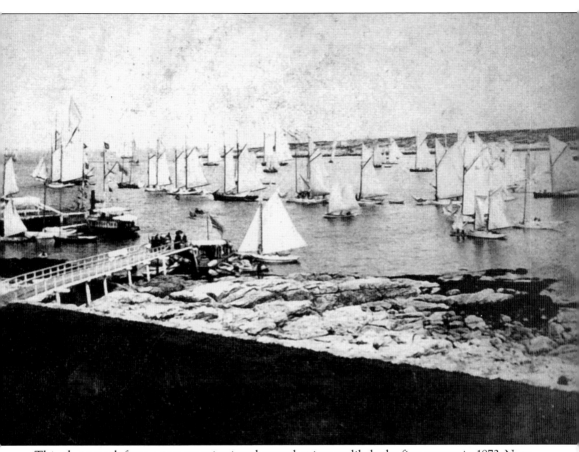

This photograph from a stereoscopic view shows what is most likely the first regatta in 1873. Note the main pier where the steamer is docked as well as the wooden pier to the right. Uncle Oscar Laighton's remarks about the regatta also included, "The race brought so many objectionable people to the Oceanic that their exclusive guests moved over to Appledore to escape the noise and confusion."

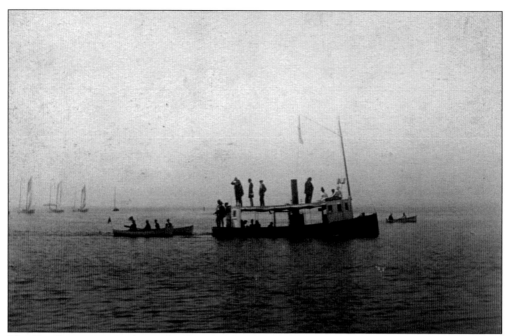

The *Pinafore* is seen in this early photograph in Gosport Harbor. She is towing two small boats with women crews under the watchful eyes of several men standing on the main and upper decks. The ladies sitting over the wheelhouse have their own male companions. In 1898, the steamboat *Pinafore* sank at Isles of Shoals during the Portland Gale.

The steamboat *Merryconeag* was a workhorse and spent most of her time working various routes in Maine, especially in the Casco Bay region. She worked in the Isles of Shoals between 1901 and 1902.

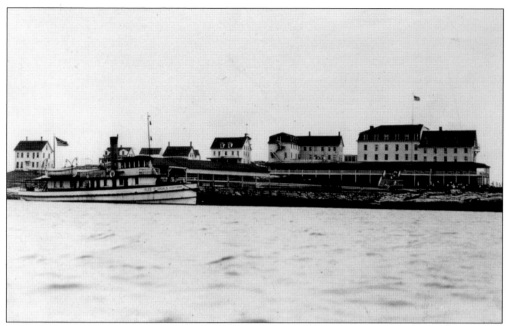

The steamboat *Sightseer* was the right type of boat to work Star Island. Her first year was 1910, and she worked on and off in the teens but steadily from 1919 to 1941. World War II halted her service, as Star Island was closed. She went to work for Uncle Sam and never came back. The *Sightseer* was like the profile of the Oceanic Hotel and the chapel, a Star Island classic.

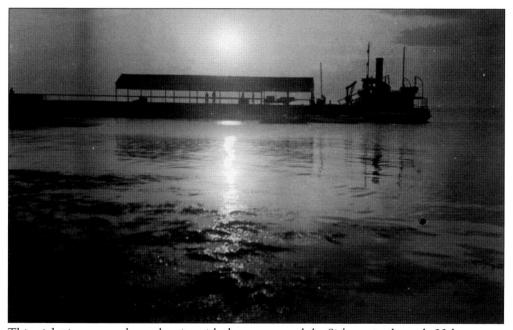

This nighttime scene shows the pier with the canopy and the *Sightseer* in the early 20th century. The exact date when the canopy on the pier came down was not found; however, it does not appear in any photographs beyond the 1940s.

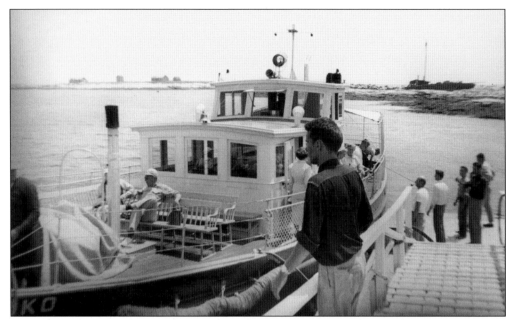

The *Kiboko*, the boat that replaced the *Sightseer*, is about to leave Star Island for Portsmouth. Note the wreck of the naval barge in the background. Star Island reopened after World War II, in 1946, and the *Kiboko* served the island from 1947 to 1961. Note the benches on the foredeck, no doubt from the Oceanic Hotel. Elliot Hall had the same style of benches until modern stackable chairs replaced them.

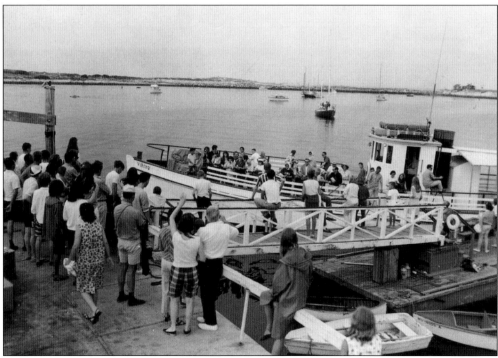

The *Viking* replaced the *Kiboko* in 1962 and ran to 1968. This picture, taken in the 1960s, shows the *Viking* on its way back to Portsmouth with casually dressed young people saying good-bye.

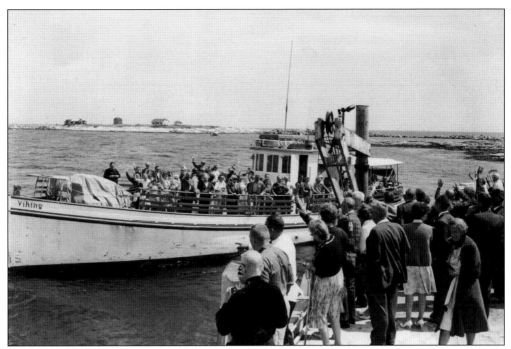

The *Viking* is leaving Star Island for Portsmouth, no doubt in a different year than in the previous photograph. Note some of the boat's details have been changed. The people on the float are older and dressed more formally than those in the previous image.

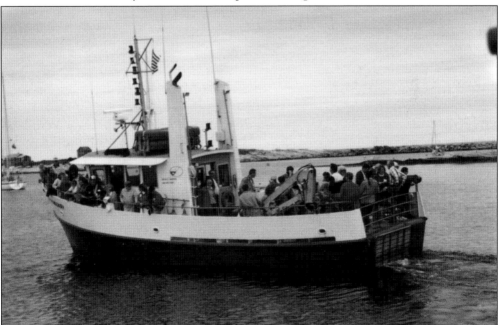

The Shoals Marine Laboratory on Appledore Island owns the research vessel *John M. Kingsbury.* Named after one of the laboratory founders, she is pictured here bringing a group of spring volunteers to Star Island. Since the 1960s, there has been an undergraduate summer program in marine science, first held at Star Island, then on Appledore Island.

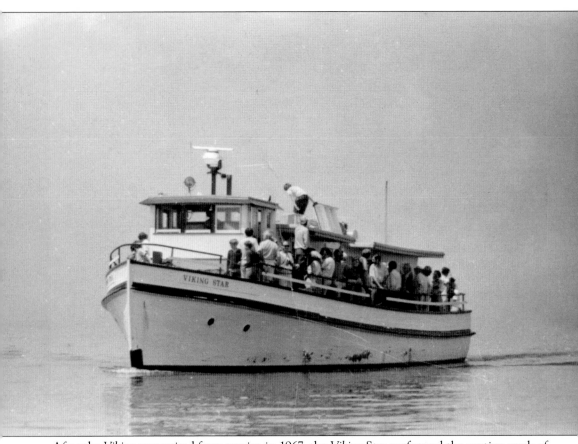

After the *Viking* was retired from service in 1967, the *Viking Star* performed the routine work of taking conferees from the mainland to Star Island. She ran between the years 1968 and 1975.

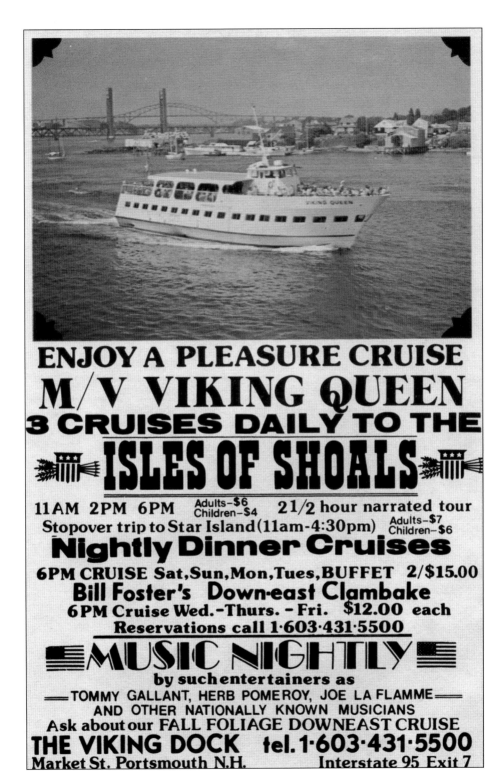

The boat to Star Island in 1974 was the M/V *Viking Queen*. She was far bigger than previous boats (500 capacity versus 100 on the old *Viking*) and more streamlined. Her service ended in 1982.

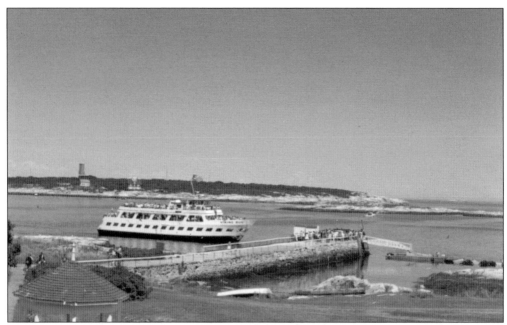

The *Viking Queen* and the *Viking Sun* served the island at the same time. The *Viking Sun* was smaller then the *Queen* but had very similar lines. The *Sun* worked from 1980 to 1987.

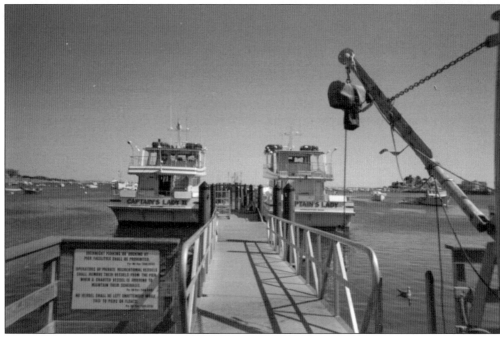

Arnold Whittaker established Viking Cruises in 1962. Arnold's son Bob and his wife, Robin, created a new company, the Isles of Shoals Steamship Company (ISSCO), with two boats—the *Oceanic* and the *Thomas Laighton*. ISSCO boats ran between 1987 and 2004. In 2000, Star Island contracted with Captains' Fishing Parties of Newburyport, Massachusetts. Pictured here docked, the *Captain's Lady* and the *Captain's Lady II* sailed to Star Island from Rye Harbor between 2005 and 2009. (Courtesy of DJC.)

Freight to and from the island could no longer be carried on the passenger service, so Rev. Bob Thayer donated a boat in memory of his late wife. The first *Pamela J. Thayer* worked from 1994 to 2000. In 2002, the island acquired a lobster boat named *Desiree's Dream*, which was renamed *Pamela J. Thayer*, the boat in this photograph. In 2010, the *Pamela J.* was replaced by the *Perseverance*.

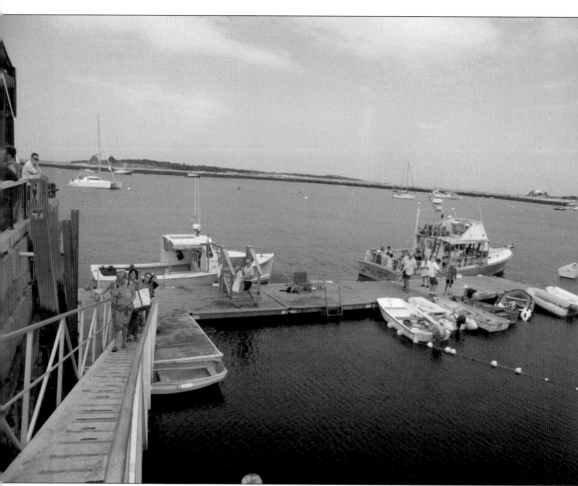

There are two boats at the float. The first is the *Miss Julie*, a Star Island–owned boat. The second boat is the *Uncle Oscar*, a private boat service to Star Island from Rye Harbor operated by Sue Reynolds, a retired schoolteacher. While teaching, Reynolds started the Lighthouse Kids in her seventh-grade classes in North Hampton, New Hampshire. The program raised funds to preserve White Island Lighthouse in 2000. (Courtesy of DJC.)

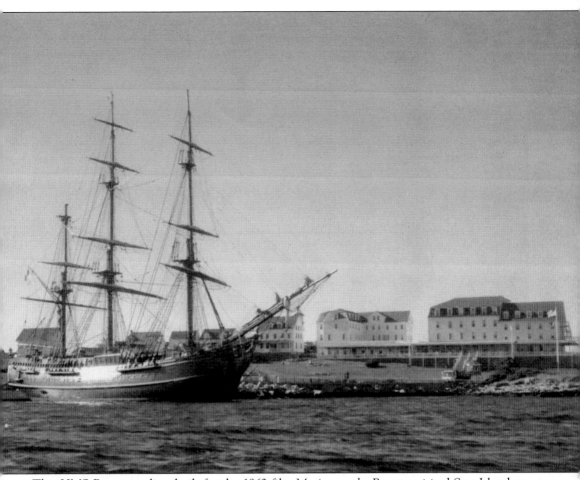

This HMS *Bounty* replica, built for the 1962 film *Mutiny on the Bounty*, visited Star Island on August 28, 2012. The crew volunteered on the island. On October 25, 2012, the *Bounty* sank in Hurricane Sandy, with the deaths of two. On August 12, 2004, the *Friendship*, a replica of an East Indiaman, visited the island from Salem National Historic Site.

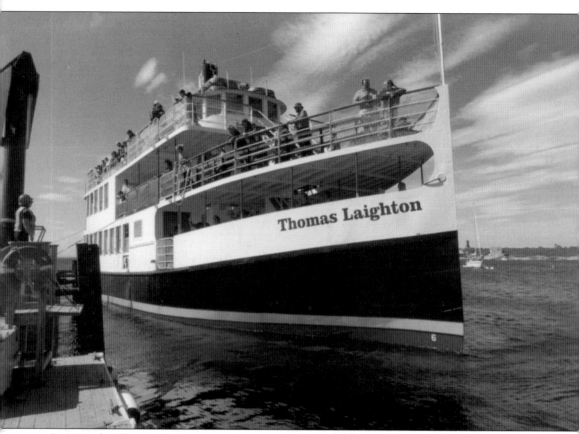

In 2010, the *Thomas Laighton* came back on the Star Island run. She was built with a water tank designed to bring drinking water out to the island. Her design reflects the steamboats that serviced the Shoals in the late 19th century. (Courtesy of DJC.)

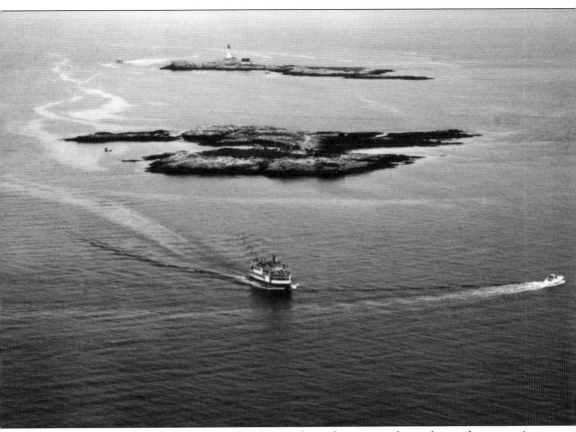

The *Thomas Laighton* brings Star Islanders home after a day or a week in what is their spirits' home. Passengers may bring home joyful thoughts and gifts of social and spiritual renewal during their stays on Star Island and immediately begin planning their returns the next summer. "You Will Come Back!"

Discover Thousands of Local History Books
Featuring Millions of Vintage Images

Arcadia Publishing, the leading local history publisher in the United States, is committed to making history accessible and meaningful through publishing books that celebrate and preserve the heritage of America's people and places.

Find more books like this at
www.arcadiapublishing.com

Search for your hometown history, your old stomping grounds, and even your favorite sports team.